100 posters 134 squirrels

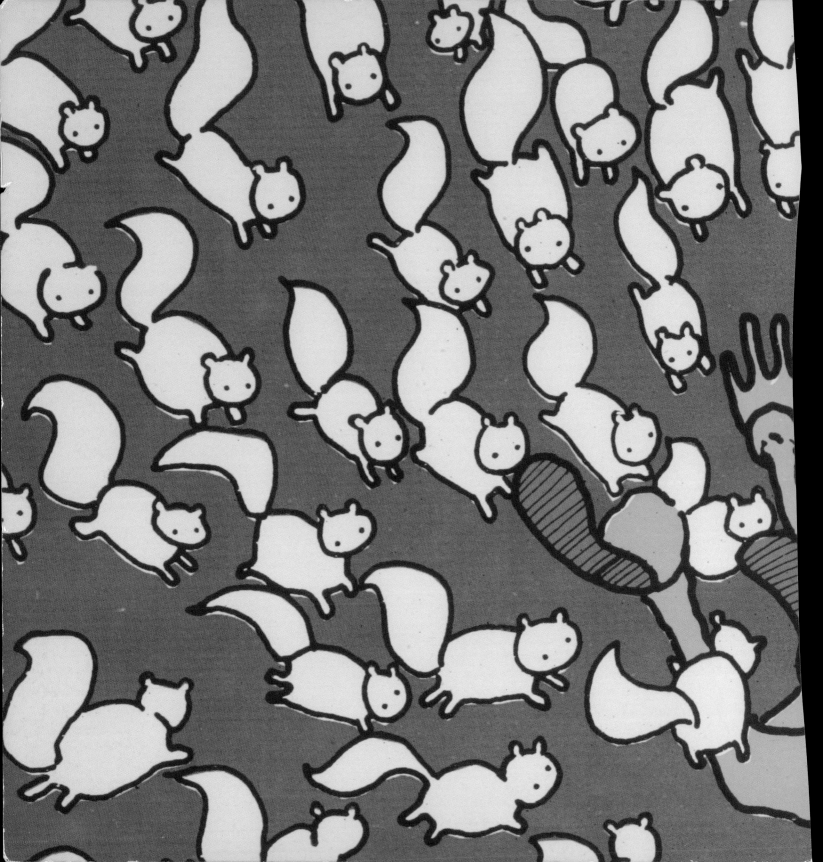

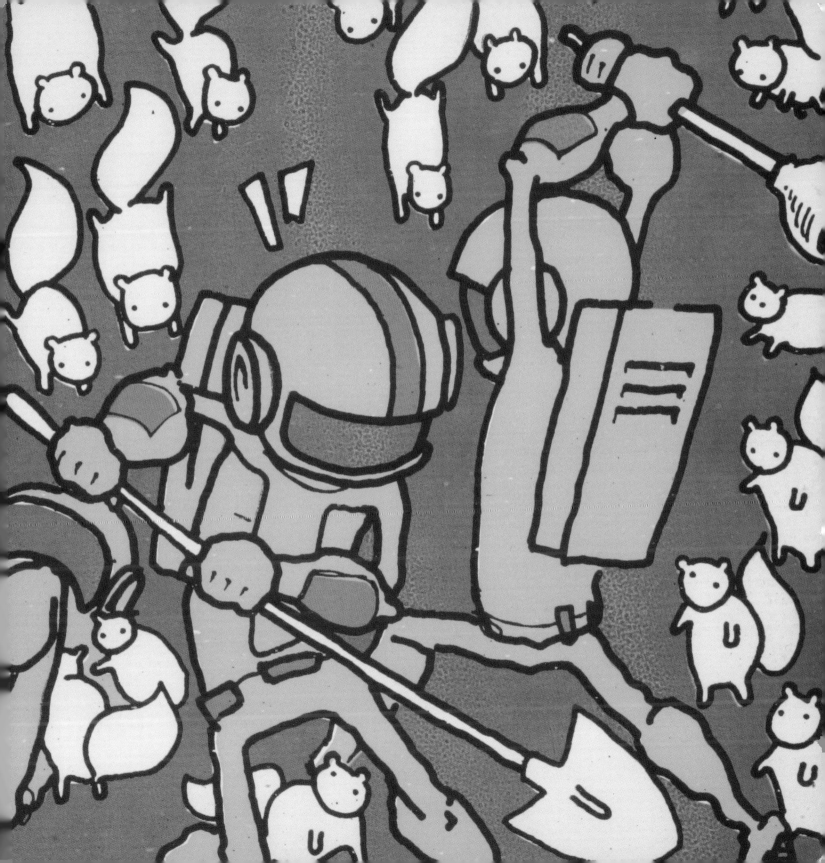

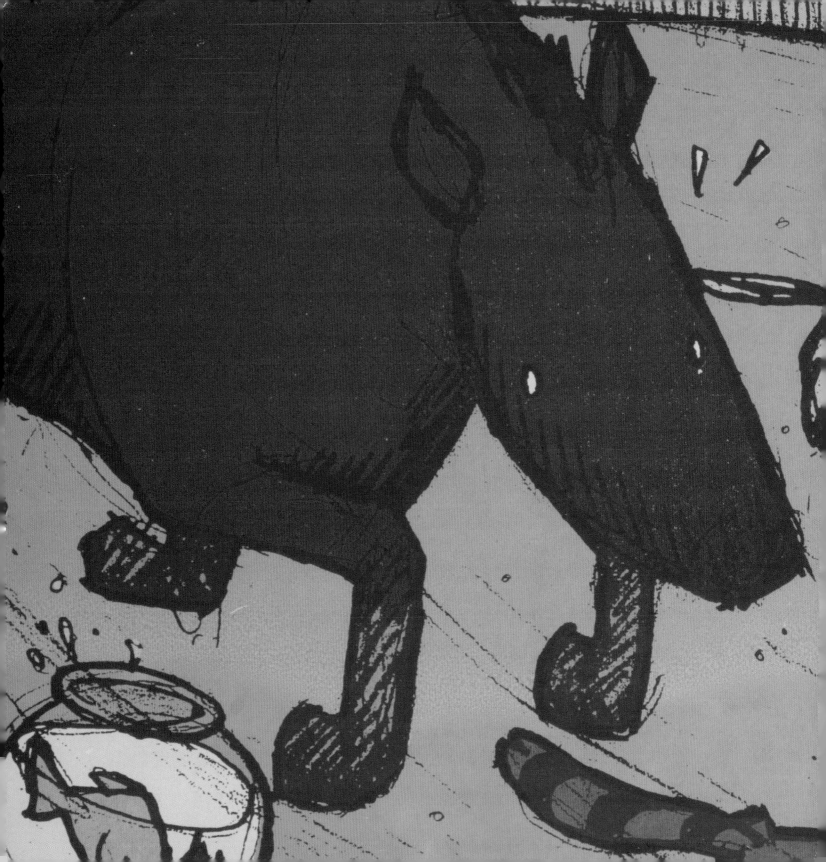

100 posters 134 squirrels

A decade of hot dogs,
large mammals, and independent rock:
the handcrafted art of Jay Ryan

With essays by Steve Albini,
Art Chantry, and Debra Parr
Introduction by Greg Kot
Poster annotations by Jay Ryan

Punk Planet Books
Chicago

Published by Punk Planet Books/Akashic Books
©2005 Jay Ryan

Punk Planet Books is a project of
Independents' Day Media.

Book design by Jason Harvey
Inside front cover photograph by David Maki
Dianogah photo on page 111 by Marty Perez
Interview photography by Jay Ryan and the staff
of the Bird Machine
All other photography by Lisa Predko

ISBN 10: 1-888451-93-9
ISBN 13: 978-1-888451-93-1

Library of Congress Control Number: 2005903219

Punk Planet Books
4229 N. Honore
Chicago, IL 60613
books@punkplanet.com
www.punkplanetbooks.com

Akashic Books
PO Box 1456
New York, NY 10009
Akashic7@aol.com
www.akashicbooks.com

contents

introduction

Greg Kot

My favorite Jay Ryan poster shows three astronauts fighting off an army of squirrels with plungers and shovels. What this amusing scene has to do with the 1998 Shellac tour it's promoting isn't immediately apparent. But I'd guess the image is in part Ryan's nod to another artist, Chesley Bonestill, whose futuristic outer-space paintings adorn the cover and gatefold sleeve of Shellac's 1998 album, *Terraform.*

Bonestill's artwork has a cold, impersonal, still-life beauty; Ryan's silkscreen exudes vibrant, squirming energy. It's a trip into his own personal space, and it's a fun place to visit. It makes me laugh to think of Shellac's Steve Albini, Todd Trainer, and Bob Weston inside those suits, a great band on a forbidden planet fighting for their lives against a bunch of single-minded rodents. My imagination wanders to a time when Albini operated a small but endlessly busy recording studio out of his attic in a northwest-side Chicago neighborhood. Just your average blue-collar Chicagoan holed up in his bungalow recording bands like Pegboy and the Jesus Lizard while defending his homestead against all sorts of vermin (some of them not even ponytailed major-label executives).

Rock is a visual as well as aural medium, and Jay Ryan's artwork is musical, in the same way that the album covers and gatefold sleeves of the '60s and '70s could be. Just as the best album art enhanced the listening experience, the best posters did more than just advertise a concert. They reflected its heat in unpredictable ways.

Poster art bloomed during the psychedelic era, when offset printing—with its hand-cut technique and old-school feel—came into vogue. Silkscreening, which had been around the rock world since the '50s but declined with the rise of offset printing a decade later, returned with a vengeance during the late '70s rise of punk. It's into this tradition that Ryan's work fits.

Silkscreening's first modern-day luminary was Frank Kozik of Austin, Texas. His eye-popping fluorescent color schemes and expert craftsmanship helped inspire a new generation of poster artists, including Steve Walters in Chicago. It was at Walters's Screwball Press that Ryan and countless other Chicago artists learned their craft in the '90s.

Kozik trafficked in neon boldness: voluptuous vixens, screaming clowns, electrified snakes, snaggle-toothed cartoon villains. Walters developed his own variations: hand-cut lettering that evoked the offset era, bright colors, and cleverly recontextualized clip art. Ryan, too, forges his own path. He prefers muted color schemes and focuses on the urgency of the process itself. He dares to leave in his "mistakes": false starts, smudges, and scuff marks. These create the illusion of hurly-burly motion, the helter-skelter of an indie-rock concert at full bore.

Ryan's humor also sets him apart. He's not just a child of the post-punk, do-it-yourself generation, but of the wryly self-deprecating independent Chicago music community. In this world, artists can't afford to take themselves too seriously. The unwritten rule is that if it's not fun, it's not worth doing. And his work reflects that sense of play and playfulness.

Consider the images: the barefoot superheroes (and apelike sidekick) pole-vaulting over a minefield of explosive cupcakes, the pail-banging drummer teetering on a pair of roll-away speaker cabinets, the violinist standing tall in a storm-tossed lifeboat. They're unpredictable, in the way the best rock 'n' roll always is.

Greg Kot is the Chicago Tribune*'s pop music critic, the author of* Wilco: Learning How to Die *(Broadway, 2004), and possibly colorblind.*

jay ryan's unique vision

In the current poster scene surrounding underground rock music, there is a huge schism between warring tribes of opposing viewpoints: amateur vs. professional, cartoonist vs. graphic designer, artist vs. hack, conservative vs. liberal, jackass vs. wimp. It's an unnerving reflection of the sociopolitical conflict in our society. Perhaps this is proper.

Jay Ryan is somehow magically able to not only bridge these deep chasms, but is able to do so effortlessly and in the process manage to avoid conflict and condemnation. He emerges from the fracas of the rock poster world as a completely realized stylist with work of true personal vision.

In the first place, Jay is one of the best draftspeople I have encountered. I've had the opportunity to actually watch him draw an image that was to be used on a poster project. He was standing, surrounded by a group of students, chatting with them, making jokes about small mammals and snide remarks about academics. All the while, his hands—seemingly a separate entity from himself—drew exquisite and confident linework. It was beautiful to watch those hands work. At times, I wondered if he even consciously knew what they were doing.

Years ago, when I first encountered Jay's work, I was struck by the eccentric images and the quality of the execution. He would create these wonderfully strange pictures and then slap some computer-generated typography into the compositions. It was jarring. I wondered why someone who could draw so beautifully didn't just draw his own lettering? Soon he began to do just that, taking his work to a higher level of authorship. His typography became as much of a stylistic signature as his images. It blended perfectly with his drawings—after all, they were by the same hand. Exquisite drawing became exquisite letter rendering.

But Jay Ryan's secret weapon is his color palate. His color sense is astonishing and, at this point, unmatched in the contemporary poster world. The only other poster artist whose color work is as strong is the graphic designer Charles Spencer Anderson. But, Anderson is primarily a generalized designer and seldom does poster work, and certainly never gigposter work. Jay's color sense would propel even mediocre design work into high art. In Martha Stewart's Kmart world, a great color scheme can sell anything to anybody as "good taste." In Jay's portfolio, however, it becomes just another reason why he is exceptional. He brings so many smart ideas to the table that his color sense is merely icing on the cake.

So in Jay Ryan, all of the rival strengths in the seething turbulent rock poster world combine to become a whole package: a great drawer/cartoonist and a great designer, the

instincts of a consummate professional and the heart of an excited amateur, a genuine artistic vision and poster advertising hackdom, and (best of all) a nice sensitive fella (a.k.a., a "wimp") with an edgy and dangerous sense of humor (a.k.a., a "jackass") who has made a personal goal of running a flying tackle on all of his close friends—and he's big! (*How big is he*, you ask? Imagine Hulk Hogan big, Sasquatch big, Paul Bunyan big. Really big!) He manages to not only bridge all the chasms of the contemporary poster world, but he easily combines them into an attractive and entertaining whole.

There are others on the rock-poster field who are interesting, even great: great illustrators (Derek Hess, Jermaine Rogers) and great cartoonists (Frank Kozik, Chris "Coop" Cooper) and great graphic designers (Aesthetic Apparatus, 33rpm), and even great "fine" artists (Serigraphie Populaire, Ron Liberti). But Jay can do—and does do—what all of these others can together. Jay Ryan has somehow managed to combine all of these skills into a seamless vision, a complete package, a whole enchilada. I can't think of anyone else doing posters today approaching this accomplishment.

Jay Ryan is unique—but what's with the squirrels, dude?

Art Chantry has been doing graphic design for nearly 35 years. In that time he has managed to slightly alter the course of the American design dialogue.

the cute factor

Debra Parr

Since 1995, Jay Ryan's silkscreened posters have achieved a cult following in the independent music scene and remain sought after by music fans and bands alike. In the context of contemporary art and design, Ryan's work brings together two popular aesthetics: the *cute* and what might be called the *new physical/mechanical*—design that turns away from the digital in favor of older technologies like the Super-8 camera, letterpress, and silkscreening.

The do-it-yourself enterprise of Ryan's indie print shop, the Bird Machine, exemplifies a trend that designer and curator Ellen Lupton notes in her catalogue essay for the 2003 Design Triennial at the Cooper-Hewitt Museum. She sees young designers becoming authors and producers of their own work—still working for clients, but establishing for themselves the freedom to develop a signature style. With Ryan's work, located in a crossover zone between art and design, it is precisely that signature style which attracts his steadily growing numbers of fans, clients, and collectors.

The cute factor in Ryan's work finds parallels everywhere at the beginning of the 21st century, including the hyper-sweetness of Japanese *kawaii*, the shimmery 3D figures that bounce and float through designer Amy Franceschini's digital landscapes, and the ephemeral, small sounds of the Icelandic band Mum. Ryan's posters are full of adorable moments and details. This winsome quality is partly due to the posing animals populating them, some next to barbecue grills, others stacked one on top of another in precariously leaning towers. His aesthetic rigorously eschews imagery of sex and drugs, instead clustering signifiers that are more subtly charged with independence and emotion. No big-breasted chicks, but rather an iconography, a menagerie of vulnerable, innocent creatures—squirrels, cats, bears, monkeys, young boys, birds—all with broad faces and wide-set eyes, regardless of species. They all seem intimately related, sharing as they do the same cute DNA of Ryan's style. It's this cuteness, unexpected in a rock 'n' roll context, that both endears and startles.

Anthropologist Sharon Kinsella writes that in Japan, cute style "betrays a lack of confidence in the very notion of the individual," referring to it as a "soft revolt," a refusal of an adult world with stringent patterns of work and responsibility. Perhaps this is the appeal to indie music fans who love Ryan's work—American youth cultures have always invented ways of negotiating the transition to adulthood. But in Ryan's posters there is no trace of Disneylike infantilization or regression to childhood. If anything, the kids—and the animals for that

matter—seem quite independent, even fiercely so at times. A 1996 poster for June of 44 and Rex depicts a young boy precariously balanced on a box that appears to be floating downriver. He's wearing a horned Viking helmet and brandishing an ax. He's got two arrows in his back and looks desperately frail, but at the same time incredibly fearless. You want to fight on his side. In many of Ryan's other posters, there is a lot of extreme fun going on—a kid furiously riding a couple of speakers mounted on tall, spindly, wheeled legs as if they were a skateboard, the rest of the sound system keeping up alongside him. But Ryan's posters, while strangely tender, are never cloyingly saccharine.

Other theorizations of the cute, such as Frances Richard's "Fifteen Theses on the Cute" (*Cabinet*, issue 4, fall 2001), suggest that the recent turn to this aesthetic by artists and designers alike hints at darker subtexts. Richard's philosophical delineations call for a serious contemplation of the cute, perhaps now more important than ever, when theories of the sublime seem more resonant with current global conditions: the ongoing war in Iraq, the troubling world dominance of the United States. The cute—oddly enough—offers alternate worlds and serves, as Richard puts it, "to displace, or neutralize, or re-conceptualize in a positive and non-threatening direction." It is, she argues, a "device of masking and semblance." In Ryan's posters, this process seems knowing, and not at all afraid of the way that it points to darker implications. Often in his work something unsettling complicates the cuteness—the sky falls, animals stampede, mayhem seems imminent. One of his illustrations for Andrew Bird's *The Mysterious Production of Eggs* is downright apocalyptic. Against the distant background of a city skyline, a sweet fluffy lamb, a chicken, and a goatlike creature sit around a picnic blanket, apparently sharing pie, coffee, and milk; the twist is that they are all on fire—towering infernos of flame and smoke spewing from their bodies. In a poster for the band TV on the Radio, a horde of delicately drawn bombs—all printed in a sweet pale baby-blue—drop from the sky, along with a lone speaker cabinet. Patently sweet squirrels watch over newborn human babies (as in a birth announcement he printed for some friends), but in another print they also take risks—*Squirrels Taking Risks* being the title of an exhibition of Ryan's work in Manchester, England—by playing with guns. It's this double register of sweetness and darkness that pulls the viewer into a recognizably horrific world, even with its imaginative displacements that make one smile.

In many of Ryan's posters, there exists an intense narrative moment of danger or panic that is almost filmic. Movies, of course, rely on one frame following another, edited to create a temporal unfolding of events. In Ryan's posters

this unfolding is truncated, and the single "frame" floats in an ambiguous space without resolution or certainty. As in the poster for the Kings of Convenience, the scene often implies an ongoing situation, but remains incomplete. In this poster the open-ended interpretation of possibilities elicits a sympathetic concern for a group of ten bearlike creatures—some with tiny tea cups in hand—clinging to thin, fragile branches of trees listing dangerously toward the ground. A threat is in the air, but the context remains mysterious, and full of portent.

The filmic moment in *Tiny Car* similarly evokes an emotional investment. This is a good example of Ryan's non-band, non-commissioned work, but that doesn't seem to impact the style at all, or the range of affectivity in the print. The point is that while never negating darkness, Ryan creates a space of emotion. In this print he zeroes in on a couple of guys in a small car. The driver—wearing dark-rimmed glasses—grips the wheel, deathly intent on the road ahead. The passenger glances fearfully out the side window at something out of the frame. Dramatic orthogonal lines create a threateningly animated landscape—while at the same time suggesting the vehicle's hurtling speed. There's no way to know for sure what's happening, but it's a poignant scene, immediately evocative, nonetheless.

Ryan's affection for his characters—human and animal alike—is matched by the clear love he has for letters. In his earliest work, digital typography jarringly competes with the line quality of his drawing, but once he starts sketching letter forms, the posters reach the kind of unity found in the best traditions, from Jules Cheret's and Alphonse Mucha's art nouveau posters to Wes Wilson's psychedelic posters of the 1960s. Ryan's lettering—and on some posters there's a lot of it—has the same emotive expressivity as his cute creatures. The ambient value of the curves and lines of hand-hewn letters can't be overestimated in the current moment of digital font saturation. There are so many new typestyles these days that anything hand-lettered—posters, CD sleeves, book covers—creates an alternative atmosphere in which the flourish of an organic line is a welcome aesthetic turn. Ryan is in good company here: Designers and artists such as Chris Ware, Stefan Sagmeister, and Edward Fella display a similar calligraphic virtuosity in their work. There is, however, something irresistible in Ryan's lettering: his quirky way of making some letters smaller than others in the same line; his hand-drawn rules to separate lines of text, building them up in an almost archeological layering; his fearless use of letters as pattern and texture. The posters are well served by his handcrafted letters, which construct a complete and very particular world.

The pull of Ryan's posters also registers at the level of the indexical—the mark, the trace of the technology creating a texture, a tactile quality. His work, produced as it is in relatively small runs at his print shop, the Bird Machine, has an anti-slick aesthetic that lends itself to his drawing and lettering style, with its concern for tiny particulars and its friendly yet intensely competent sense of line. The physical materiality of Ryan's posters presents a sincere alternative to digital slickness—there's a sense of immediacy, authenticity, and, to use a phrase of theorist Hal Foster, a return to the *real*, a real that is endearingly low-tech. You can feel the layers of ink laid down in the physical pull of the squeegee across the surface of the paper. The handmade texture of Ryan's posters is further enhanced by his love of inexpensive, degradable substrates like thin newsprint and chipboard—a cheap, rough, brown uncoated stock that materially signals a refusal of the slick.

It is within the context of the digital, however, that Ryan's fanciful anti-aesthetic finds its significance, its distinctive flavor. As the writer Momus points out in an essay on the current fascination with the very mundane materiality of paper, new media seem transparent, while the old seem opaque. That is, in the look of the new media one can see the obvious technological limitations of the old. The digital appears to eclipse and make obsolete the medium of printed paper. There is, nonetheless, in the experience of the new, Momus argues, a "revelation that former media were in fact limited, metaphoric." This opacity of old media is not without its charms and attractions. Unlike transparency, which is often all about ambition and power, opacity can, he further explains, be "winning, cute, full of flavor." He muses:

> What is flavor but situation; the refusal to be everywhere, the failure to represent everything? The consolation prize for not being the Universal is getting to be the Particular. The consolation prize for not having power is having flavor. The consolation prize for not being transparent is being opaque. Just as photography freed painting to do what it did best—be paint on canvas rather than a "window on the world"—so computers are freeing paper to be white stuff with marks on it.

In the case of Ryan's very winning, very flavorful posters, computers free paper to be that stuff with incredibly labor-intensive, low-tech—but amazingly cute—marks on it.

Debra Parr is a professor of art and design history at Columbia College Chicago. She writes for Merge: Sound Thought Image, *published in Sweden, and is also writing a book on youth cultures and design, including a chapter on all things cute. She lives in the Logan Square neighborhood with her boyfriend and three cats.*

pictures that don't wink at you

Steve Albini

"Jay, it's Steve." *"Hello. How are you?"*
"I'm fine. Hey, we need a poster for this tour we're
 doing. Can you do something about Wisconsin?"
"Cheeseheads?" "Yeah, but there's a tape machine."
"How much Wisconsin?" "Lay it on thick."

So goes the client/artist collaboration: Jay Ryan, a genius who makes screenprint posters, takes the germ of an idea (his, mine, yours—it could even be from a catalog of them) and makes it uniquely great. With the thing in hand, we first admire it, then gape at it, then puzzle over it. Then it becomes clear in an *Aha!* that nearly slaps the smile off us.

Jay's genius is in knowing what matters and what doesn't. What matters is getting the idea across, not making an academically perfect rendering—though he is not above doing that if it's the best way to get the idea across. His genius is in having the image matter. The image is never an excuse to show off the craft of executing it.

Craft: what a hideous word. It conjures images of macramé and glitter glue. Craft is—I concede— a starting point. But save your huzzas. Of course it is executed well, you idiot, that's the starting point. Pride in craft is a meaningless distraction for the technician, housewife, or wannabe bereft of ideas. Done exceptionally well,

a stupid idea is still stupid. Why even consider the starting point, the part that doesn't matter? To do so is to insult the artist, as one would to congratulate Fred Astaire for not tripping as he exits a taxi. Of course it is done well.

"Can I have the space-suit guys being attacked by squirrels?"

Jay, you can do whatever you like. Of course: attack them with squirrels. Float the kid in midair with his limbs akimbo in adolescent clumsiness. If you leave the preliminary drawing visible, then we'll see how many possibilities are open to us. Your whimsy is my half-recollected memory of sexual awakening, or skinning my knees, or fearing getting in the batter's box, or kicking my skateboard out from under me, or plugging into a real amplifier for the first time. You have it down cold, my friend. You know what is important; now just show it to the people.

"I think they're mammals of some sort."

Your whimsy is my frustration at the limitation of language. If only I could speak in words that may or may not be mammals. I sometimes adopt a fake Italian accent in attempt to enrich my conversation. You get it by sticking a zeppelin or a shovel or something in there, or maybe an undifferentiated mammal. I envy you and your vocabulary.

And what license you take with it! It's a goddamn gigposter. Time, date, and name are sufficient.

But then suddenly it's all hobbyhorses and rockets and a torso convulsed with laughter or a bowlegged running gait. You toss these images off like they're nothing, and make this mundane bit of promotional claptrap into a thing we covet, steal (when no one's looking), and hang above our beds. You dignify the event. And often enough, the gig itself fades into nothingness. The singer dropped his pants, the crowd drank hard and tried to get laid, there was that crazy girl who hung out by the bathroom all night laughing at nothing. But I can't remember the details. Long forgotten, the gig lives on, thumbtacked to the wall in the living room, or framed under glass, or rolled-up in a box with a dozen others.

When I am old, I will unroll all of them and sit among them on the floor bawling my eyes out. How dare you make them outlive me. Jay, you're a real bastard.

"Do you have a problem with bear suits or anything?"

Hell no, I don't have a problem. *You* have a problem. You have dim-witted clients who don't appreciate how much better your ideas are than theirs. You could out-art those assholes with one hand tied behind your back. The problem is that they know it and insist on tying that hand behind your back, just to see.

Relax. It's all water under the bridge. You'll have your fair share of them, Jay. Just grit your teeth, get your pencils out, and give yourself a week to forget about it. Before long, you'll get another phone call from some band or some book publisher or some shoemaker, and he'll say, "It's all up to you this time." And in those moments, you catch air under your shirt and fly like a goddamn box kite.

Jay, I've never told you this before, but the best thing about your images is that they're not cute. Cuteness (somehow "kitsch" isn't insulting enough, because German words always sound cool) is dumb and cheap. So cheap that sheets of stick-on cute come ten for a buck. So dumb I can describe it without seeing it. Here goes: a pinup girl and some dice and a fireball and some iconic cartoon character or anime kid with big eyes. And put a gun somewhere. And be sure the nipples poke out a little. That's the dumb part for you, but cheap is probably worse.

Your images are never dumber than you are, and you are really smart. A bad image is one that winks at viewers, letting them know you half-assed it and you didn't give a shit. Your pictures don't wink, Jay. I can tell you're not faking it. Look at all your contemporaries— hell, look at the pantheon of the entire history of the genre. They wink like strobe lights.

Thank you for not winking at me, Jay.

Steve Albini has lived in Chicago since 1980. Before that, he was a child. He has been in the bands Big Black, Rapeman, and Shellac, and currently owns Electrical Audio, a recording studio.

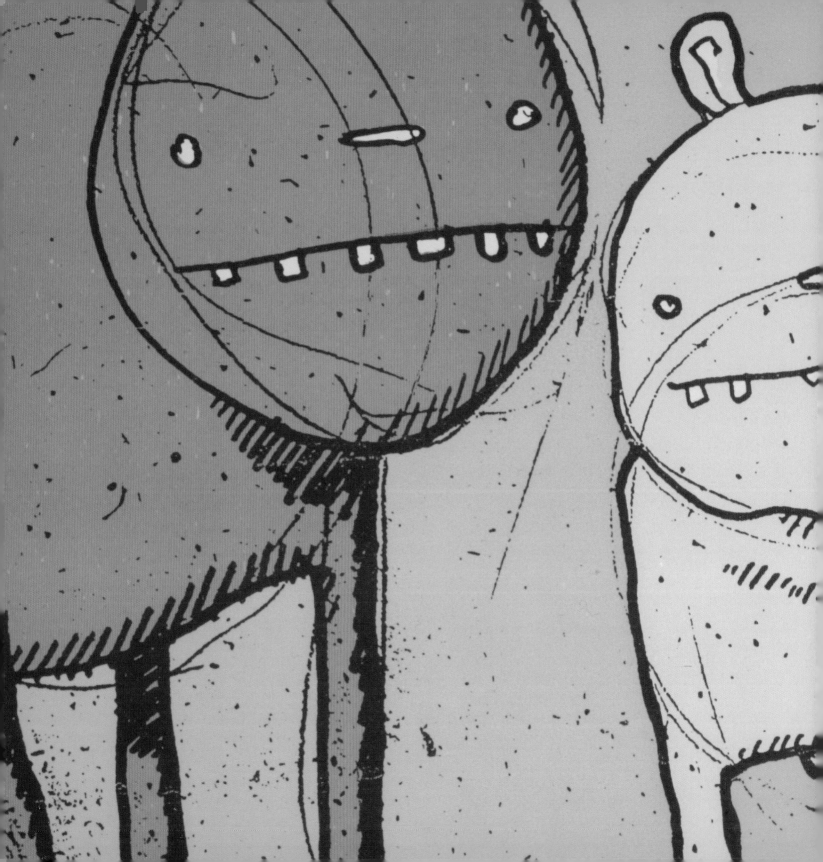

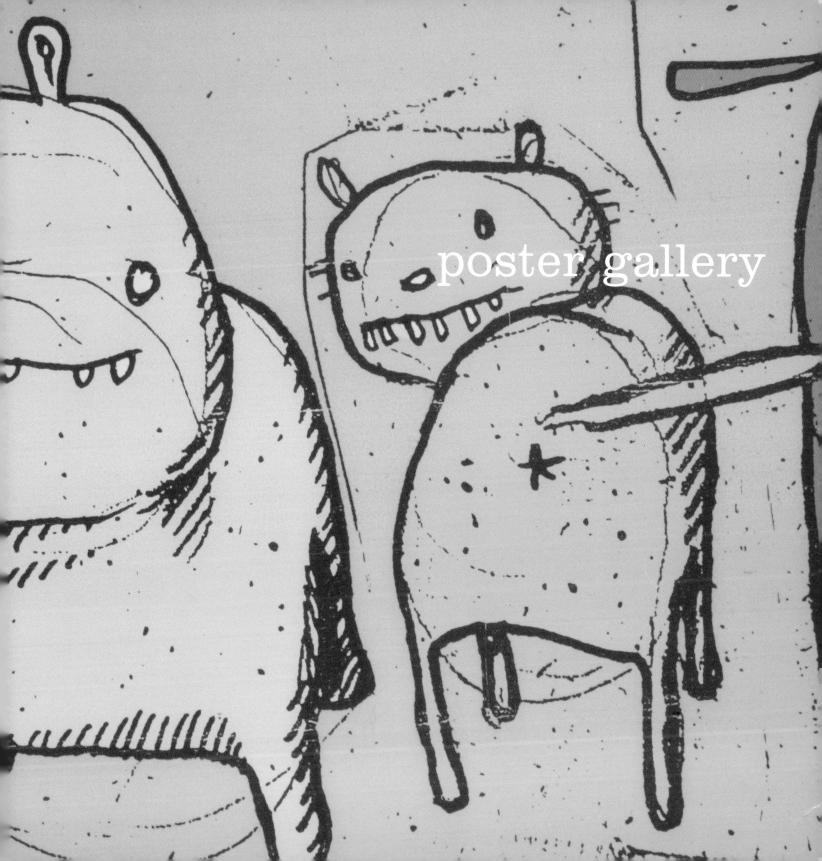

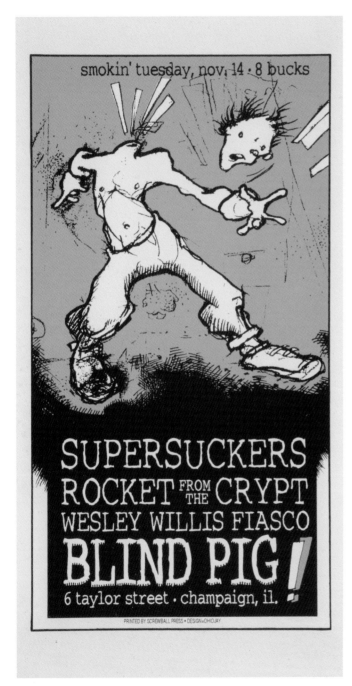

**SUPERSUCKERS /
ROCKET FROM THE CRYPT /
WESLEY WILLIS**
1995
12.5 x 24 inches
2 screens

*This was the first poster I
worked on. Andy Mueller from
the Ohio Girl Company and I
learned about how to set up
screenprinted posters together
while making this.*

002
SILKWORM / SIXTO / .22
1999
13 x 18 inches
2 screens

003
THE WRENS / THE RACE
2004
12.5 x 19 inches
4 screens

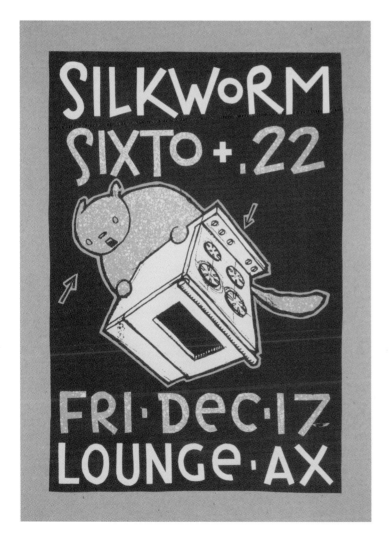

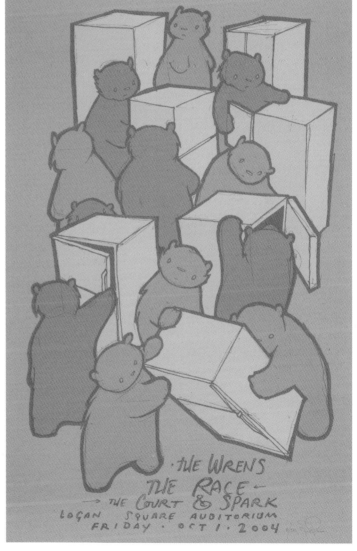

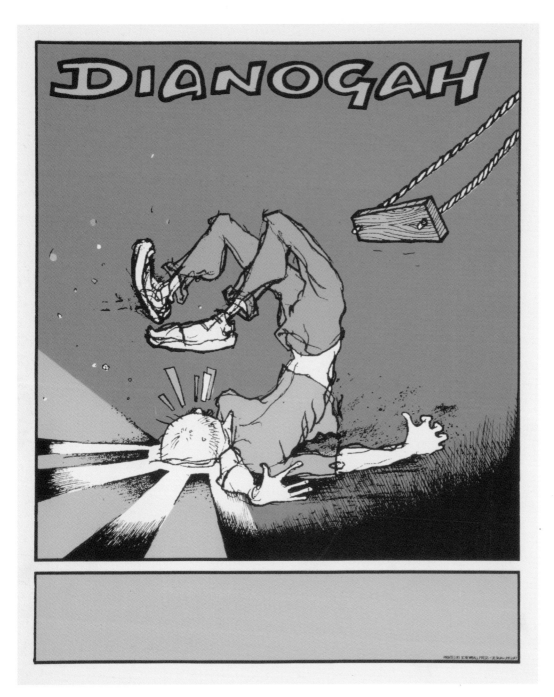

004

DIANOGAH
1995
18 x 22 inches
3 screens

SILKWORM / DIANOGAH
1998
24 x 18 inches
3 screens

While drawing this poster, I was amused to discover that Kip's horse (second from the right) had fallen asleep while smoking.

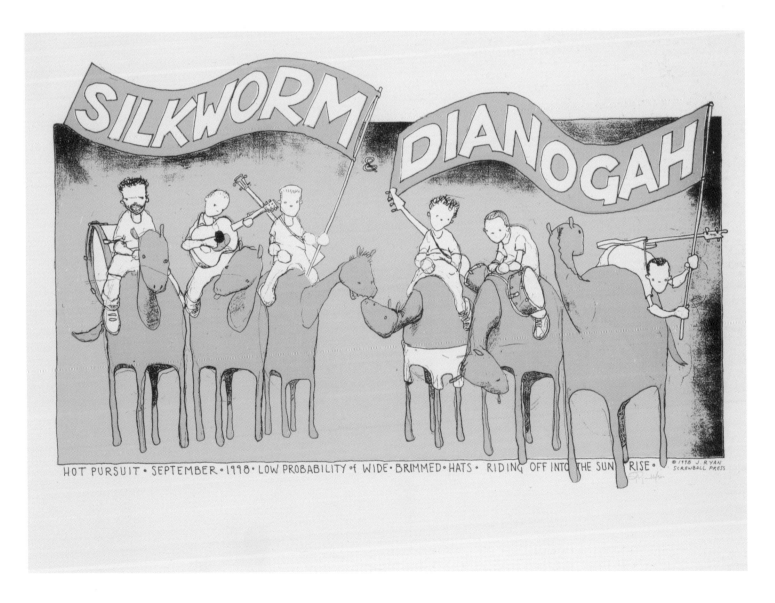

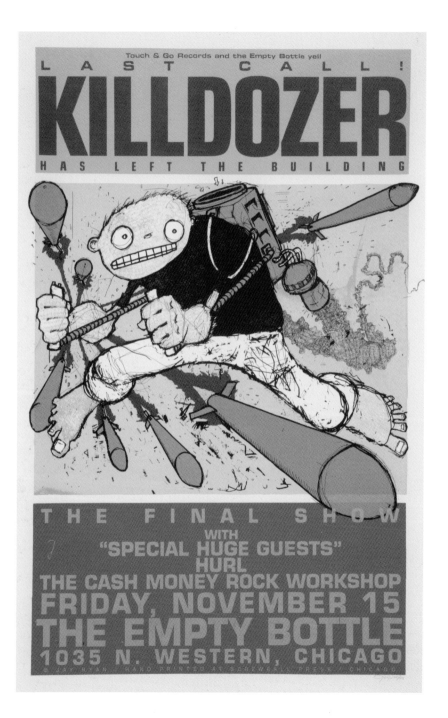

006

KILLDOZER "FINAL SHOW"
1996
22.5 x 35 inches
9 screens
original artwork detail
(opposite)

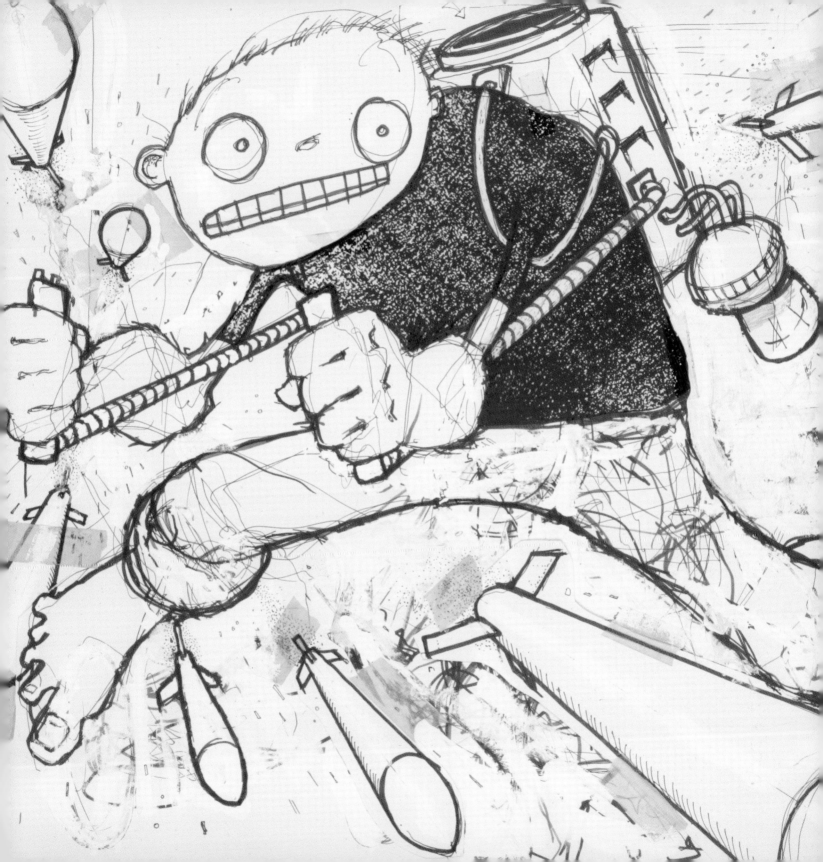

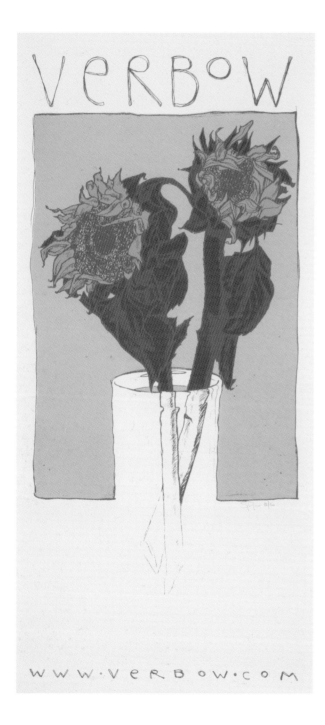

VERBOW

www·verbow·com

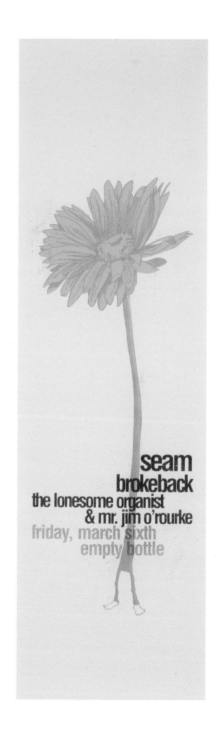

seam
brokeback
the lonesome organist
& mr. jim o'rourke
friday, march sixth
empty bottle

**LOREN MAZZACANE /
JIM O'ROURKE**
1996
22.5 x 17.5 inches
4 screens

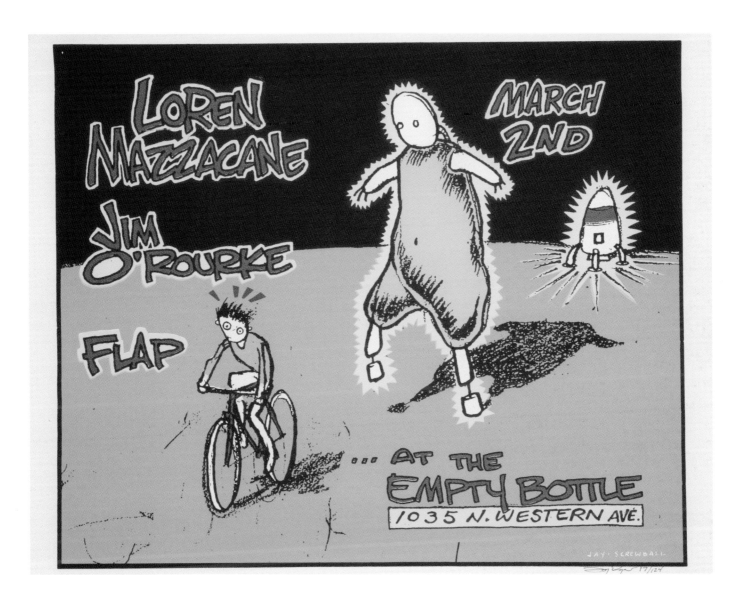

EDINBORO STUDENT
ART LEAGUE
2003
20 x 24 inches
5 screens

The art-school Yak describes
what he was trying to accomplish
with his painting, but he has a
hard time talking about his work
at class critiques such as this one.

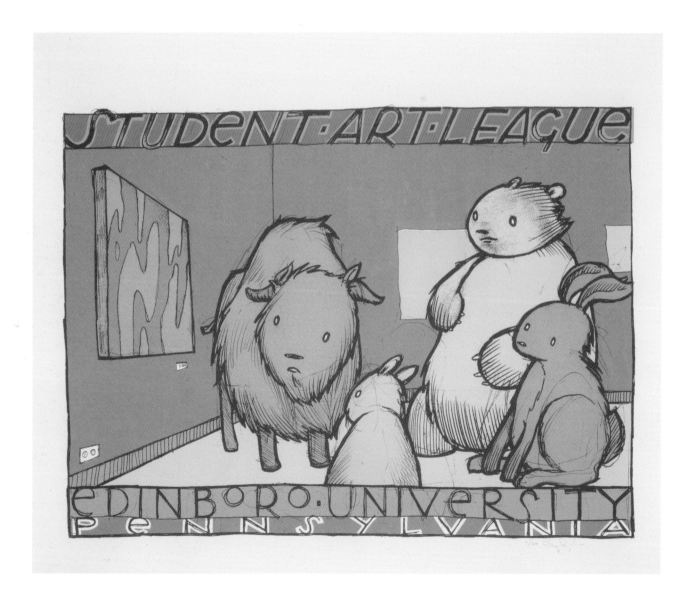

011

THE ANIMALS OF PRINCE EDWARD ISLAND
2003
19 x 25 inches
6 screens

The Atlantic Veterinary College commissioned this as a promotional item and as a gift for their graduating students. Seth the greyhound appears in the upper right corner. The poster was about to get printed when I got an e-mail asking if fish could be included, as they do a lot of work with fish at the school. Q: How does a fish run along with the rest of the animals? A: His bowl gets placed on wheels.

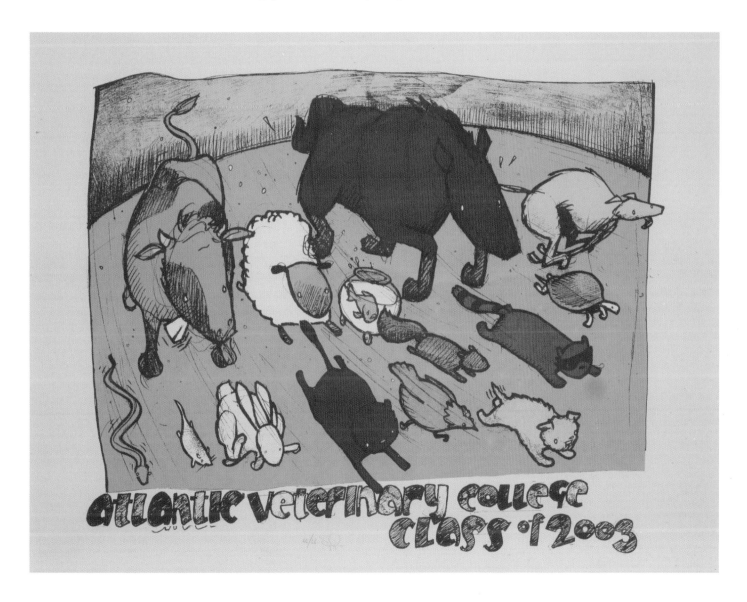

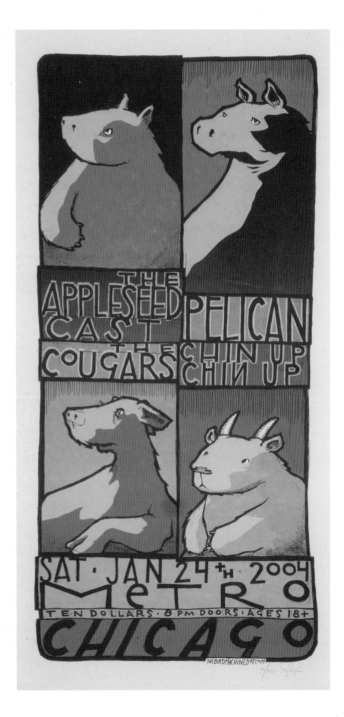

THE APPLESEED CAST /
PELICAN
2003
12 x 24 inches
4 screens
detail (opposite)

COLUMBIA CREST WINERY
2004
19 x 25 inches
9 screens

This is one of the most involved posters I've ever worked on. DDB Seattle, the ad agency who hired me, flew two people from Seattle to Chicago to make sure we got the colors right when we mixed the ink. This ran as a full-page ad in wine magazines.

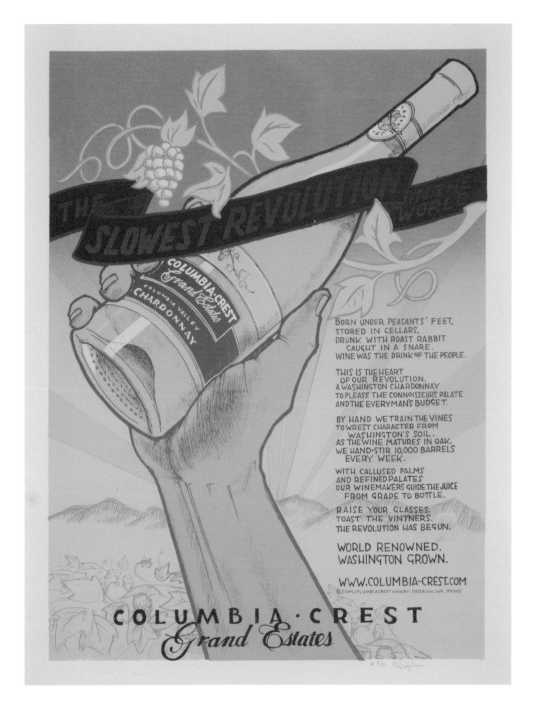

014

METROPOLIS COFFEE
2003
12.5 x 19 inches
2 screens

Metropolis is a great coffee house on the far north side of Chicago. This image was based on their existing visual identity, which was created by Scout, a graphic designer currently living in Milwaukee.

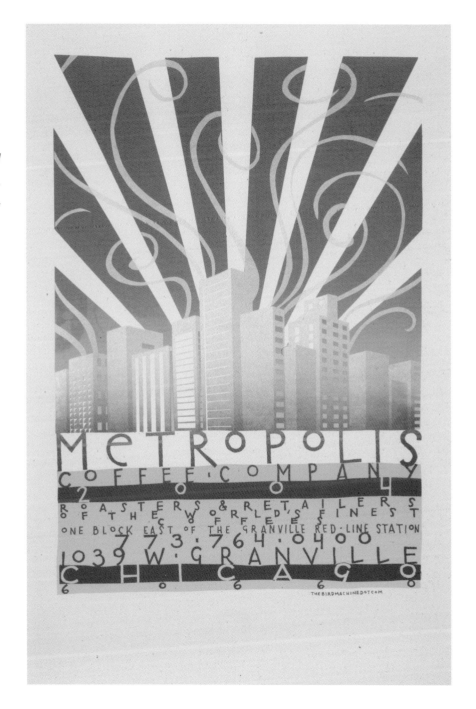

015

EVERLASTING THE WAY
2000
12 x 24 inches
4 screens

016

JEFF MUELLER /
EIFFEL TOWER
1999
12 x 24 inches
4 screens

Two posters (from a series of three) for Monitor Records. The print on the right had to include visual elements from the covers of two unrelated albums. This was the most graceful way I could think of to accomplish this goal.

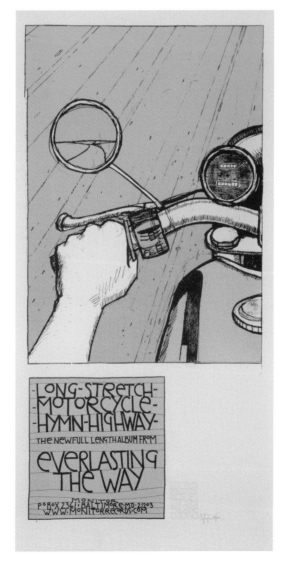

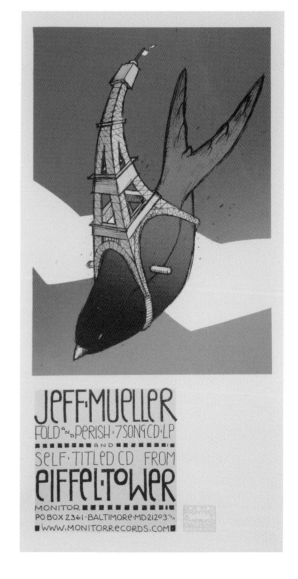

017
NONAGON
2004
12 x 24 inches
3 screens

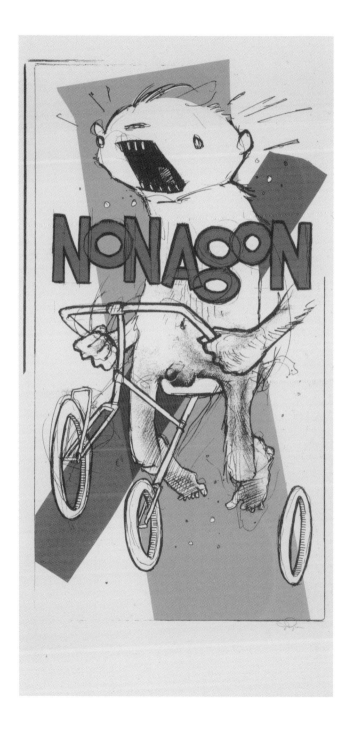

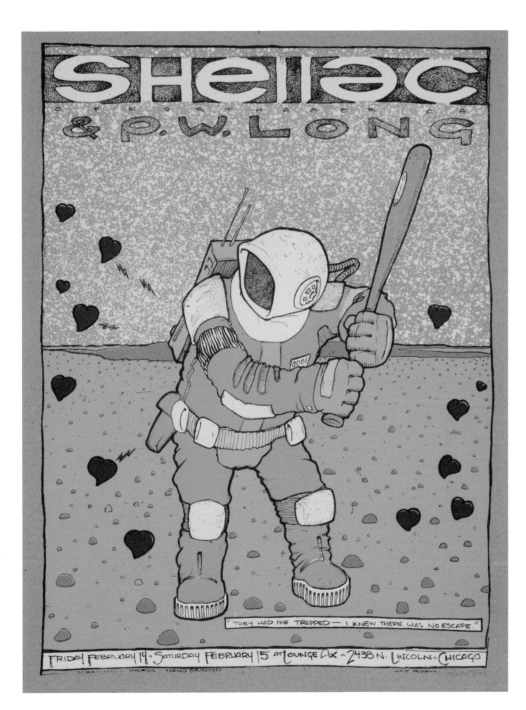

018

SHELLAC / P.W. LONG
1997
17 x 22.5 inches
7 screens

SHELLAC

New Year's Eve
with SCRAWL
at Lounge Ax
2438 N.Lincoln, Chicago
$10 advance tickets at Lounge Ax
doors: 9 p.m.
scrawl: 10 p.m.
shellac: 11:30 p.m.
free champagne and party favors
December 31, 1997

please do not ask steve to play the immigrant song

New Year's Day
with the NERVES
at the Fireside Bowl
2646 W Fullerton, Chicago
$5 advance tickets at the Fireside
doors: 10 a.m.!
first band (coin toss decides): 10:30 a.m.!
free pop tarts
espresso drinks for sale
January 1, 1998

please do not ask Bob when the new album is coming out

HAND PRINTED AT SCREWBALL PRESS, CHICAGO. (773) 645- 3581 © 1997

020
IDA
1998
15 x 26 inches
5 screens
original pencil drawing
(opposite)

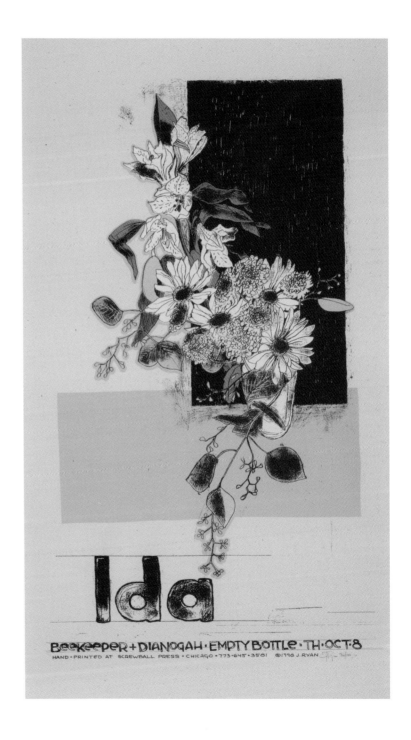

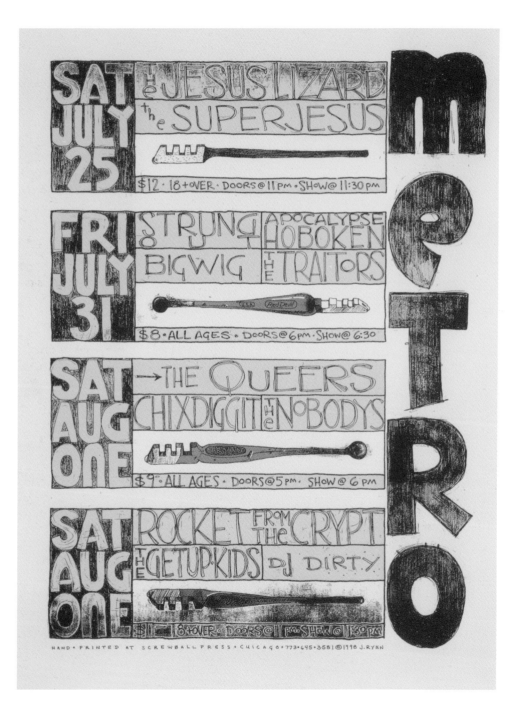

021

**FOUR SHOWS AT
THE METRO**
1998
18 x 24 inches
3 screens

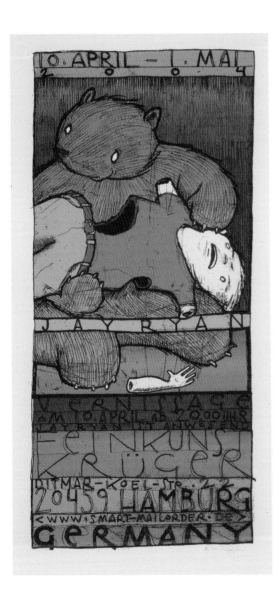

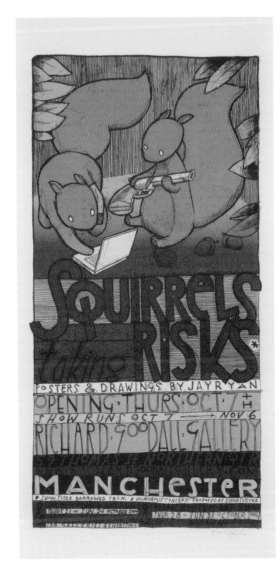

022

JAY RYAN AT FEINKUNST KRÜGER

2004
12 x 24 inches
5 screens

023

SQUIRRELS TAKING RISKS

2004
12 x 24 inches
5 screens

Left to their own devices, they probably would.

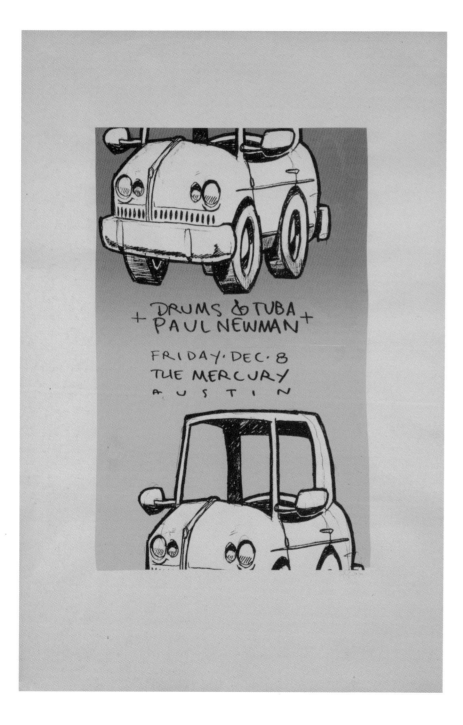

**DRUMS & TUBA /
PAUL NEWMAN**
2000
24 x 36 inches
2 screens

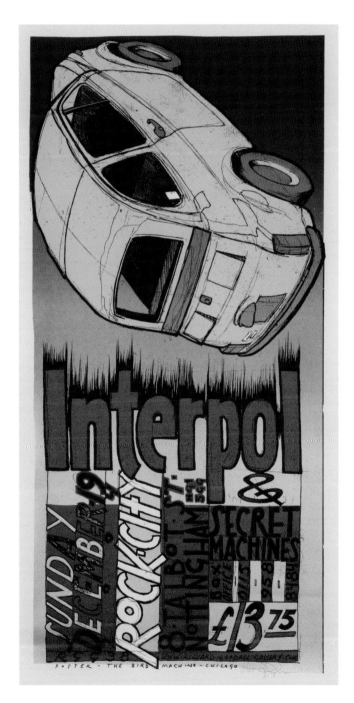

INTERPOL
2004
12 x 24 inches
4 screens

I took a lot of photos of the smallest cars I could find while in Europe. This little Fiat was parked in Rome.

026

WHAT A SURPRISE!
1997
11 x 26.25 inches
2 screeens

027

KILOWATTHOURS
2002
12 x 24
3 screens

*A reinterpretation of
Kilowatthours' album cover.*

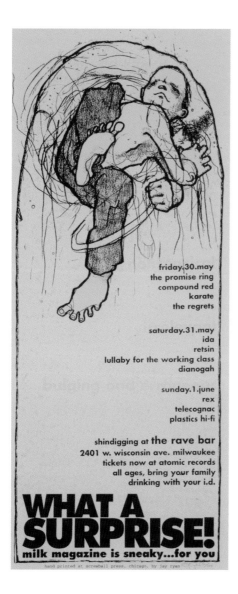

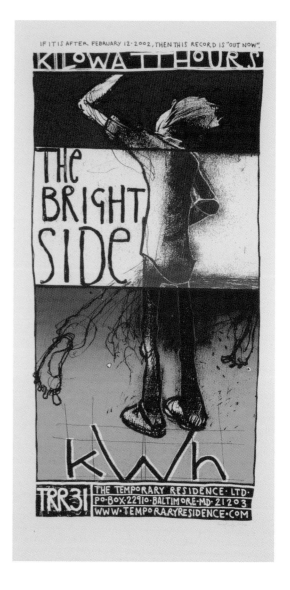

LUSTRE KING
1996
20 x 22 inches
4 screens

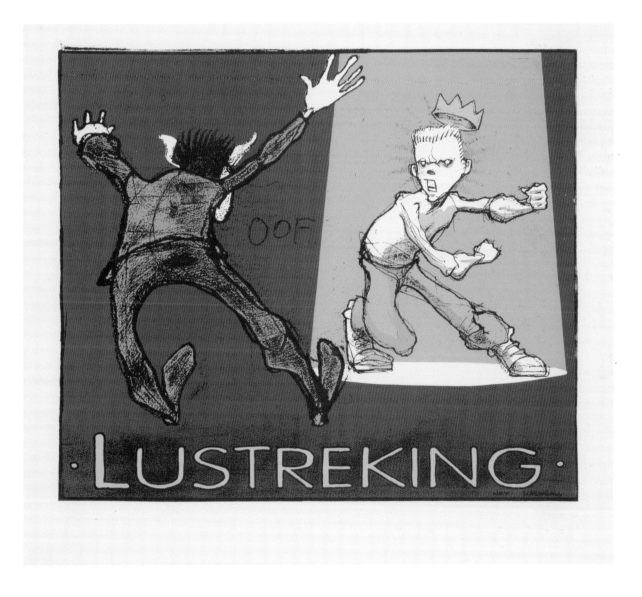

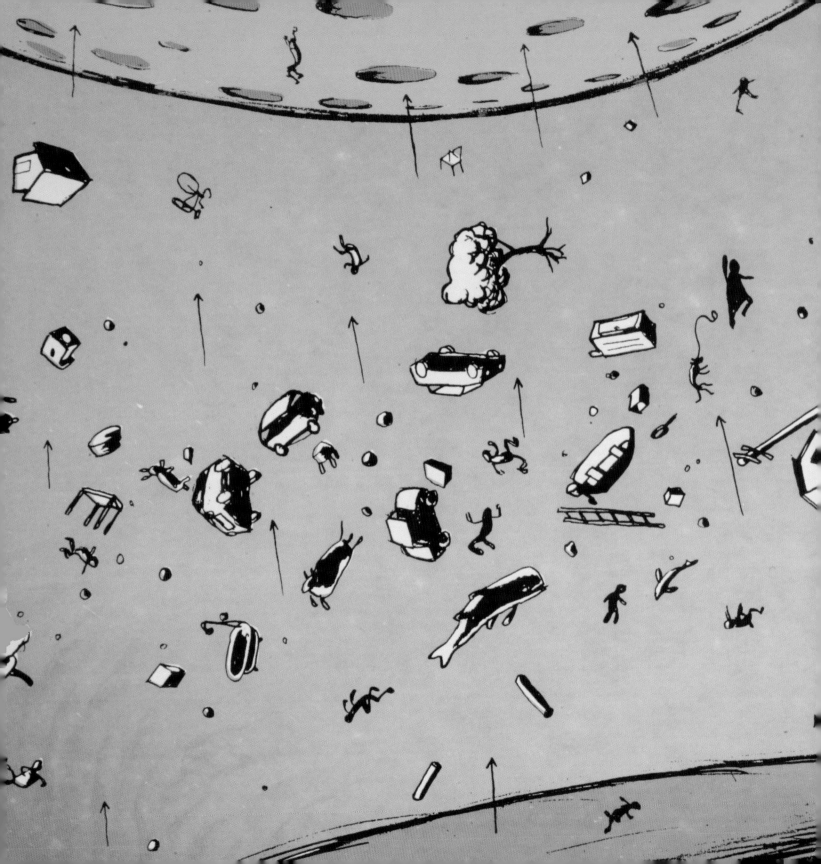

**THE NEW YEAR /
SILKWORM**
2003
12 x 24 inches
3 screens
detail (opposite)

*This image was inspired by
a Rockwell Kent illustration
about the end of the world,
which appeared in* Life
magazine in 1939.

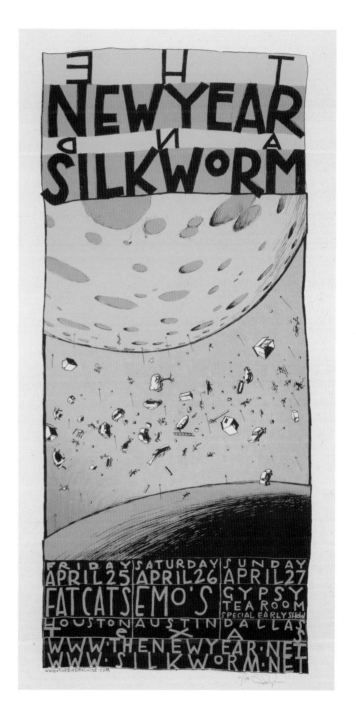

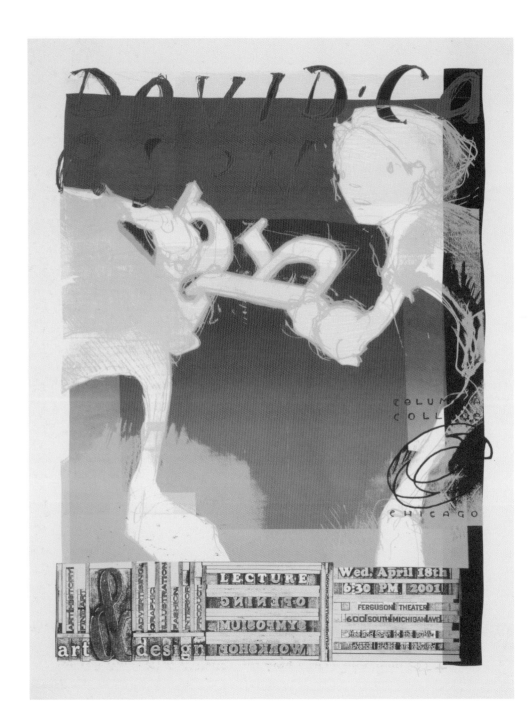

**DAVID CARSON AT
COLUMBIA COLLEGE
CHICAGO**
2001
19 x 25 inches
10 screens

*When I was young and more
impressionable (specifically
around 1986-'89), I read
Transworld Skateboarding
magazine religiously. It was a
door to where I wanted to
be: in some bright, fractured
place tearing down the street
on my skateboard. I later
found out the whole look of
the magazine was created by
David Carson, a young
designer who eventually
became a main force in
"destroying" the readability of
type in the 1990s. This
poster was my take on what
I imagined David Carson's
design process to be. I
should have included a ball
falling from the character's
hands. (Carson missed his
flight and didn't make the
speaking engagement this
poster advertises.) The
letterpress type at the bottom
of the poster was hand-set
and then scanned by
Jennifer Farrell.*

COPPER PRESS MAGAZINE
1999
18 x 24 inches
4 screens

HUBCAP / PROJECT DAN
1998
12 x 24 inches
2 screens

These rabbits also appear in the Hum / Dianogah / Heroic Doses poster (page 58), which was made at the same time.

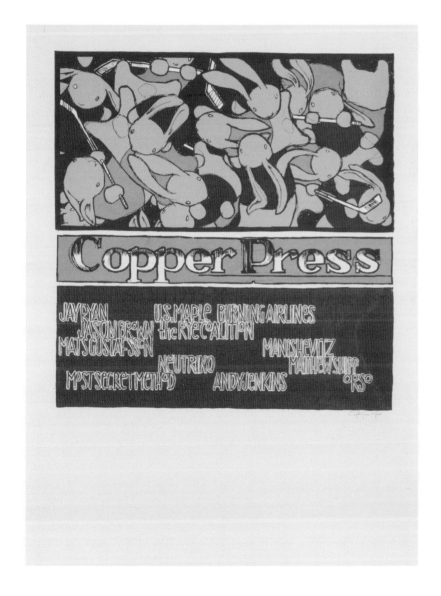

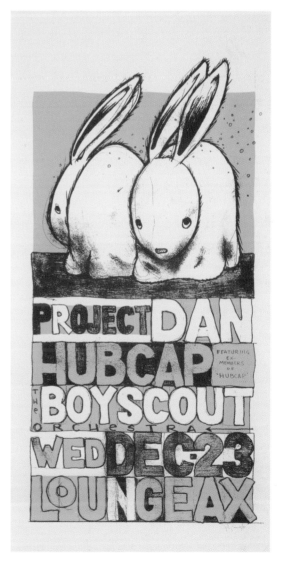

033

CHICAGO INDEPENDENT
POSTER ART SHOW
EXHIBITION POSTER
1999
12 x 24 inches
3 screens

034

WATERY, DOMESTIC
EXHIBITION POSTER
2002
8.5 x 22 inches
4 screens

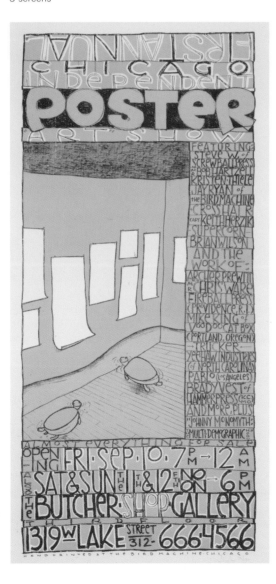

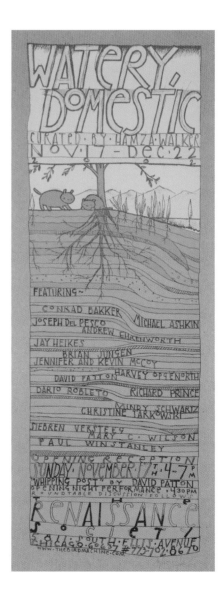

50 ISSUES OF *PUNK PLANET*
2002
13 x 18 inches
3 screens

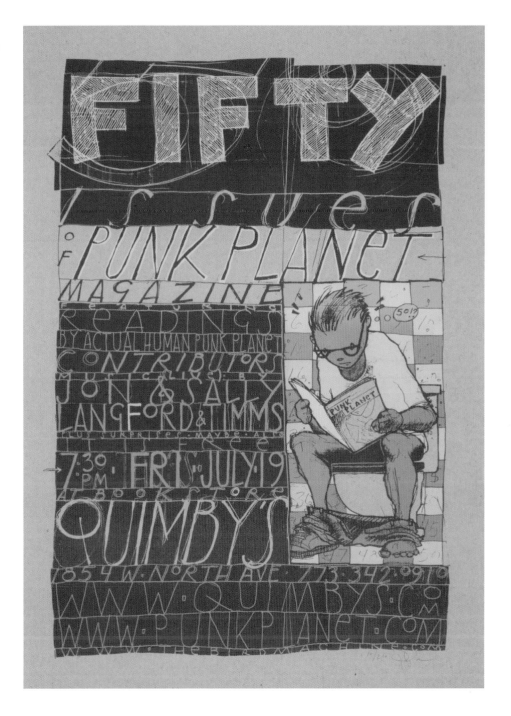

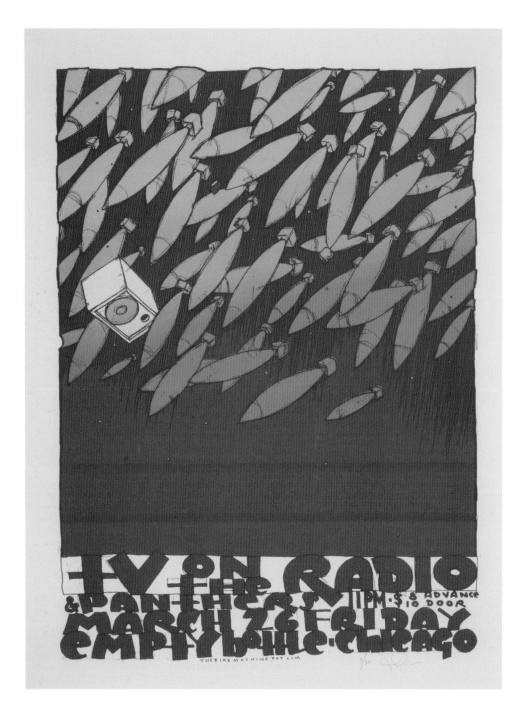

036

TV ON THE RADIO
2004
18 x 24 inches
3 screens

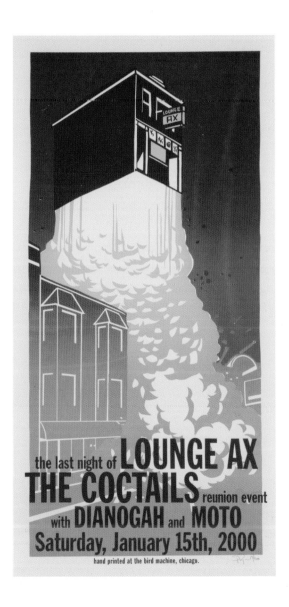

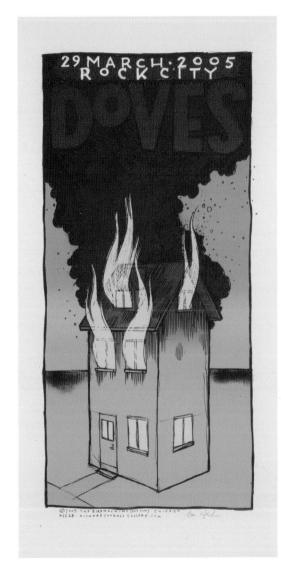

**"LAST NIGHT OF LOUNGE
AX" / THE COCTAILS**
2000
12 x 24 inches
4 screens

*I love to imagine that this
was the glorious fate of this
important Chicago rock
institution. Sadly, after many
years of regular greatness,
and a final mind-bending
two-week period of big-name
final appearances, this
friendly bar reluctantly
closed its doors. The
building sat vacant for
years before reopening as
a crappy wine bar.*

DOVES
2005
12 X 24 inches
5 screens

*"It was a day like this and
my house burned down,"
is the first line from one of
my favorite Doves songs.*

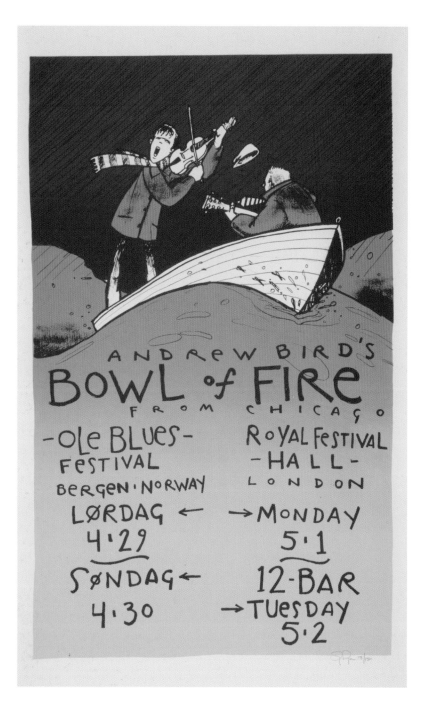

039

ANDREW BIRD
2000
12 x 19.5 inches
3 screens
original pencil drawing detail
(opposite)

*This is how I imagined my
friend Andrew would first
arrive in Norway.*

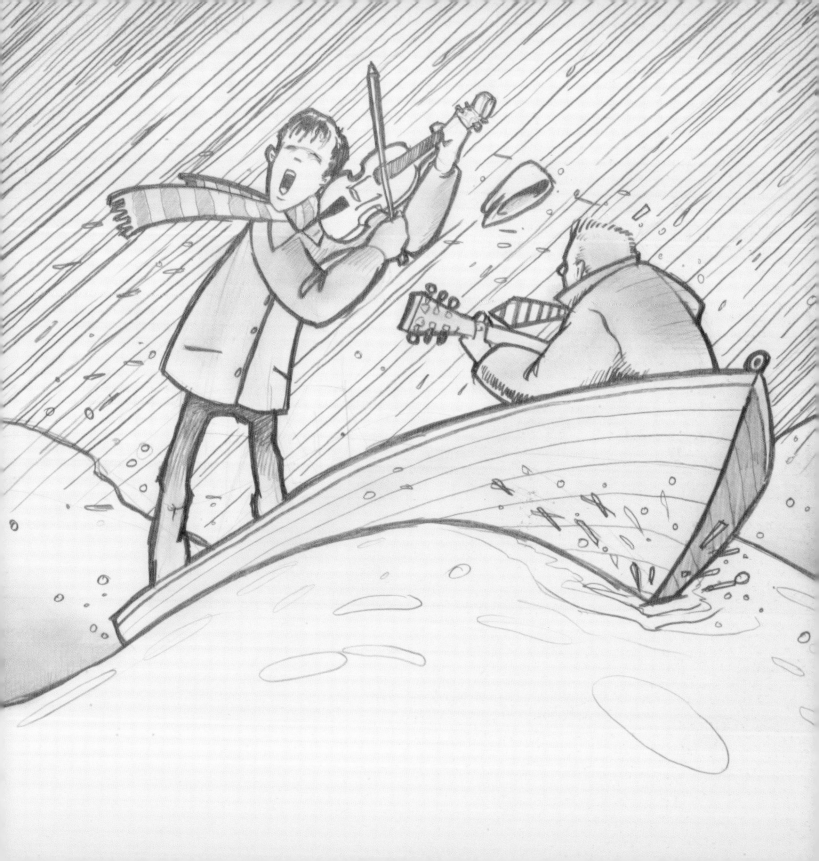

ANDREW BIRD
"BANKING ON A MYTH"
2005
19 x 25 inches
6 screens

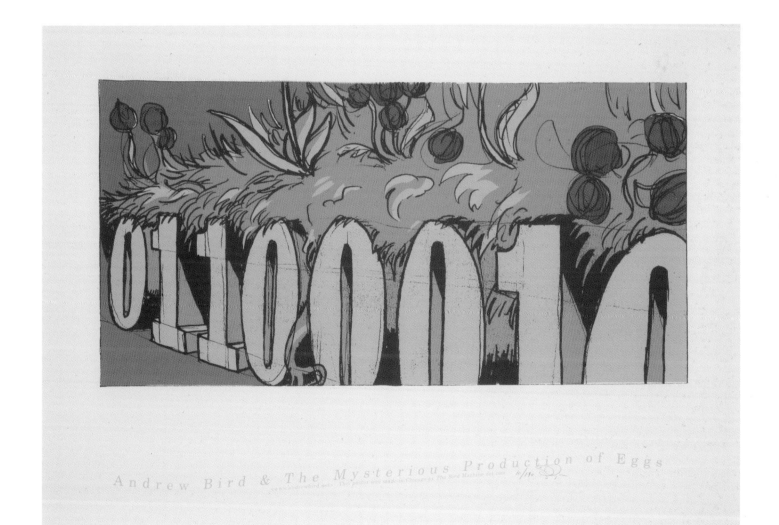

ANDREW BIRD
"MX MISSILES"
2005
19 x 25 inches
5 screens

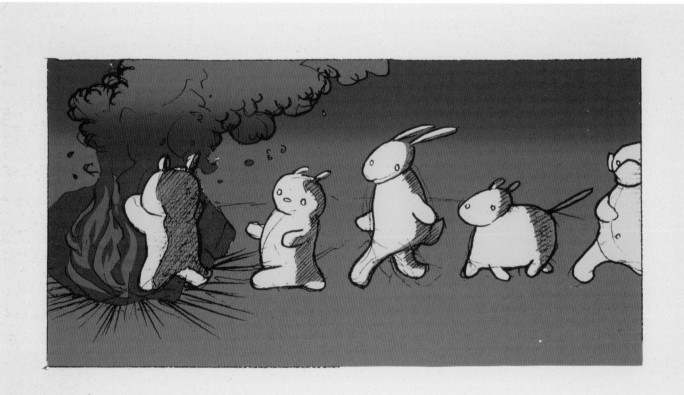

043

ANDREW BIRD
"CAPITAL I"
2005
19 x 25 inches
6 screens

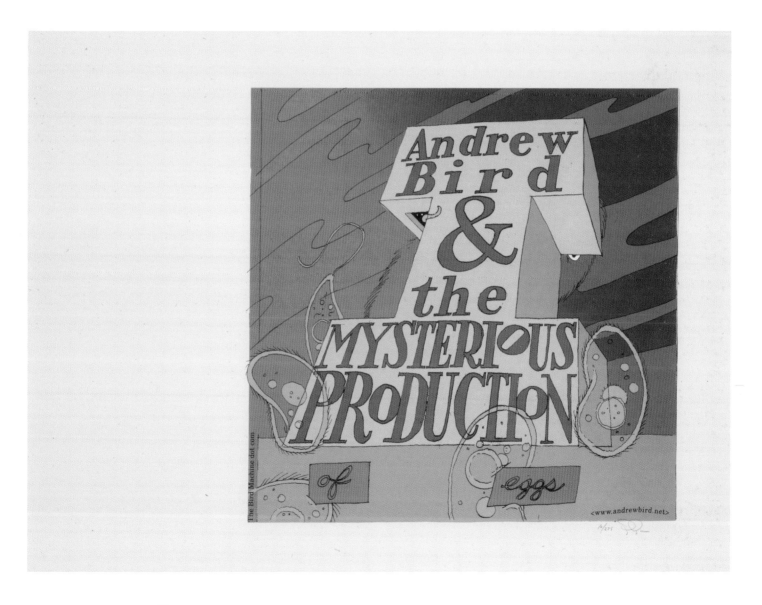

044

BUSH W/BOMB
2002
12 x 24 inches
4 screens

A poster for a preemptive benefit concert to raise money for humanitarian aid to be sent to a country we (in the United States) were about to invade when this print was made.

WAKE UP!
2004
20 x 28 inches
5 screens

*I still can't believe that
people would reelect a
president who is so blatantly
working against the best
interests of the people.*

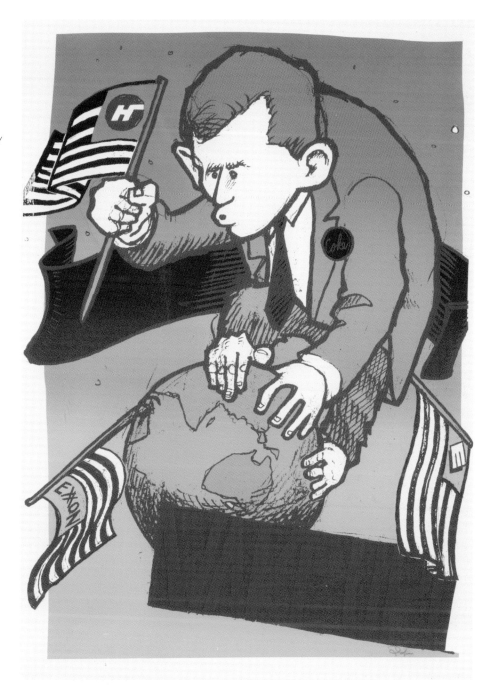

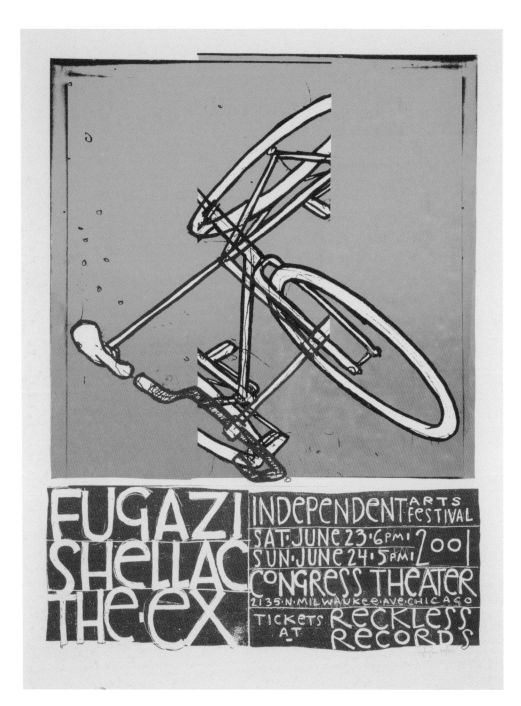

047
FUGAZI & SHELLAC
1998
24 x 18 inches
6 screens

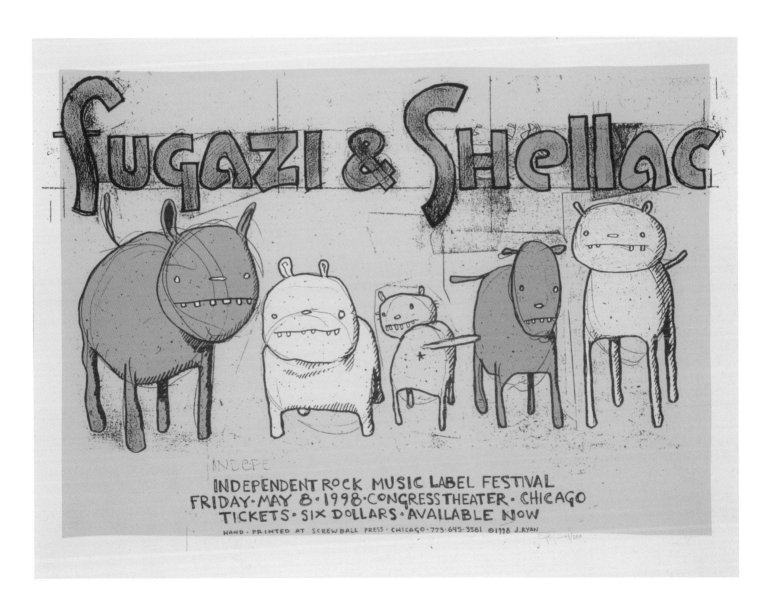

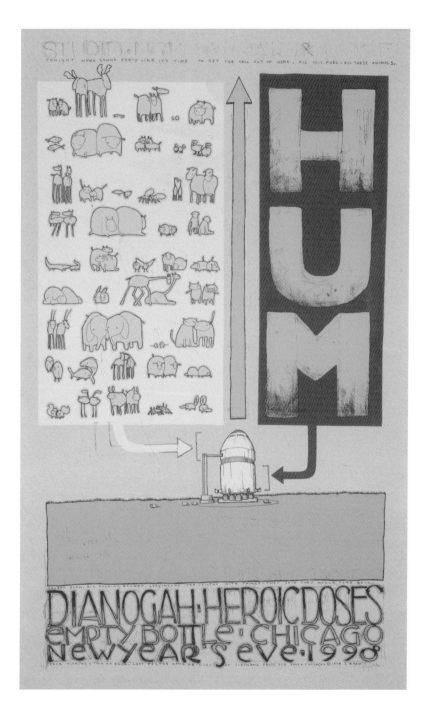

**HUM / DIANOGAH /
HEROIC DOSES**
1998
21 x 34.5 inches
9 screens
original pencil drawing detail
(opposite)

*Hum was a band from
Champaign, Illinois who
wrote enormous songs about
astronauts, whales, and girls.
This is my version of Hum's
Ark, based on what I thought
were the lyrics for their song
"The Scientists": "I said,
'What on Earth are all these
animals for?' She said,
'Exactly—we're not gonna
wait around here any more.'"
It turns out, they're singing
'ampules,' not 'animals,'
which not only renders this
poster nonsensical, but also
explains why my band
Dianogah plays mostly
instrumental music.*

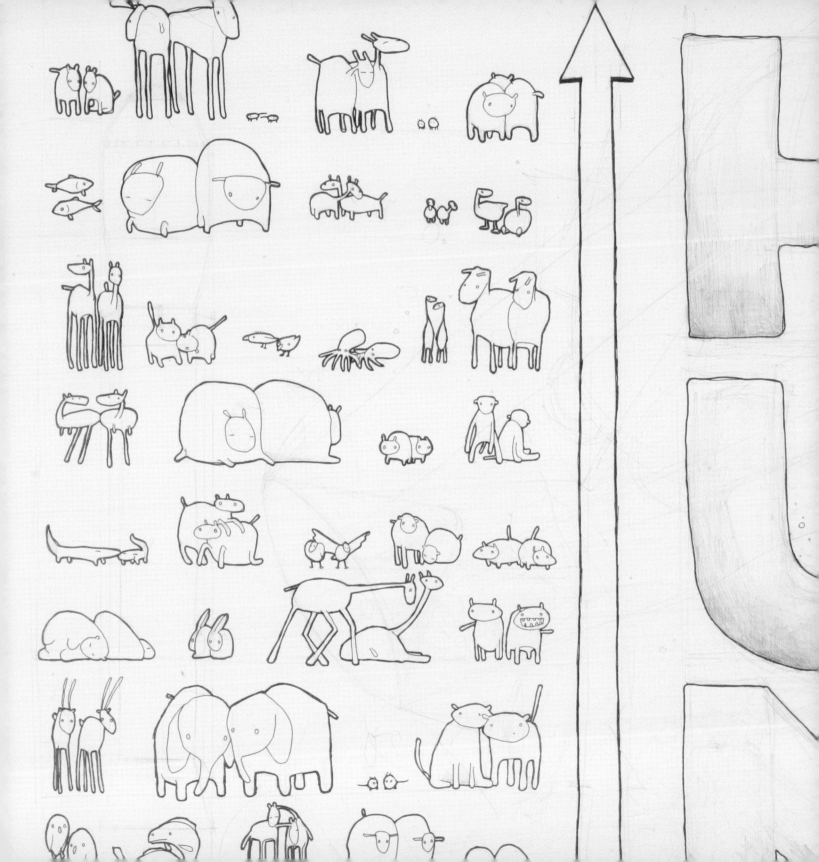

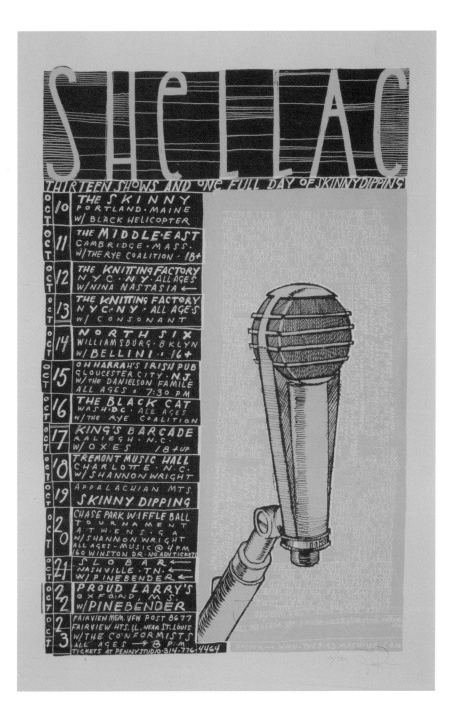

049

SHELLAC
2002
12.5 x 19 inches
2 screens

*Two of the members of
Shellac have day jobs as
recording engineers and are
especially fond of vintage
recording equipment—in this
case, a Russian-made LOMO
microphone. The texture
printed behind the image of
the mic is hand-written text
from the LOMO website,
in badly translated English.*

050

**SHELLAC "WEST
COAST TOUR"**
1998
12 x 24 inches
3 screens

*Despite what you may have
read elsewhere in this book,
the conversation, as I recall
it, actually went like this:*

*"So, Steve, for this new
poster, can I use those
astronauts again?"*

*"Sure, that'd be great,
but feel free to use some
of your undifferentiated
mammals, as well."*

"Any particular mammals?"

*"Well, I'm not suggesting
anything specific, but
we did just write a song
about squirrels."*

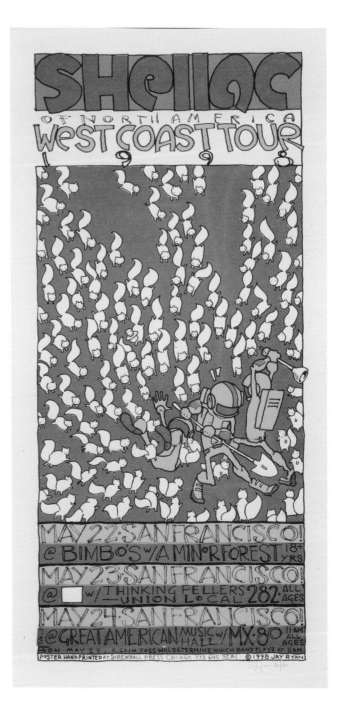

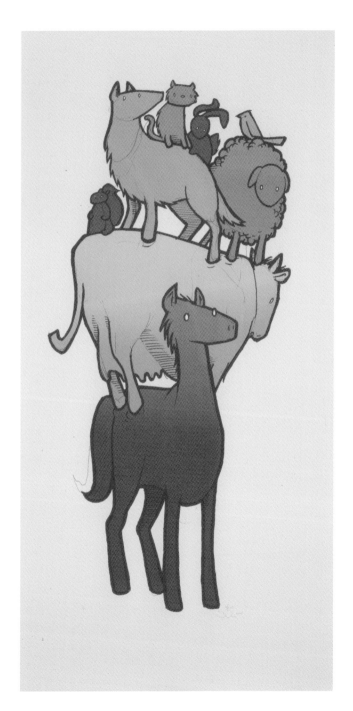

051

ANIMAL STACK
2004
18 x 36 inches
5 screens

*This image started as
a rejected concept for the
"Animals of Prince Edward
Island" poster, but ended up
being used for this art print.
It was hard to do at first,
but all came together once
we got the cow up on top
of the horse.*

193 FISH
2003
38 x 24 inches
4 screens

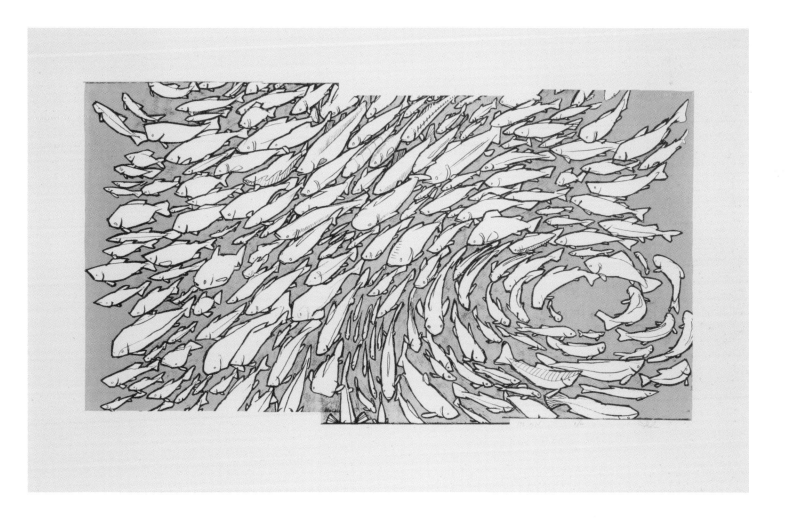

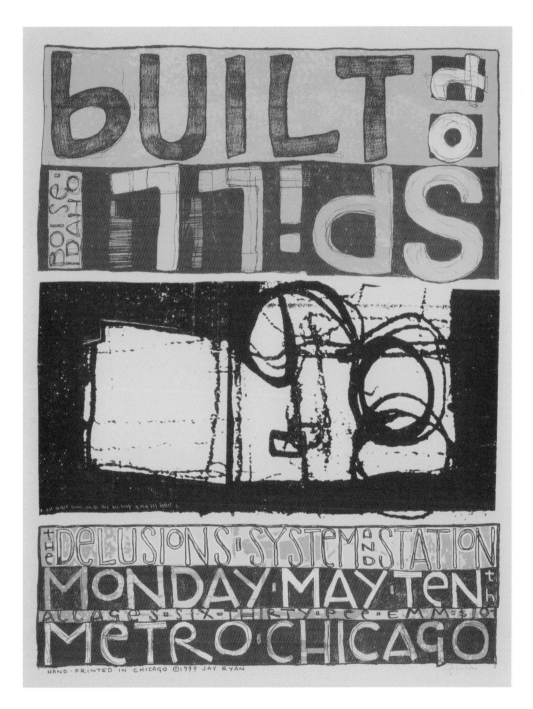

053

BUILT TO SPILL
1999
20 x 26 inches
8 screens

MEMBRAPHONICS
2001
12 x 24 inches
3 screens

A poster called "Membraphonics" for a record called MembraNAphonics. Lesson: It's a good idea to check the spelling of unfamiliar words with the client before printing.

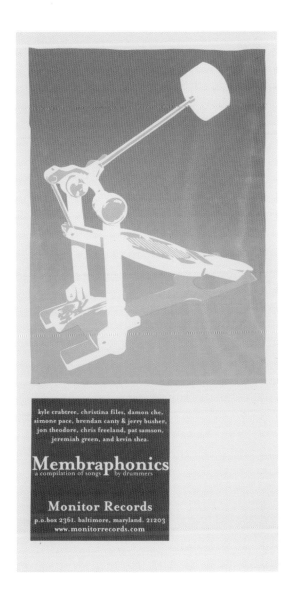

**FOUR SHOWS AT
THE METRO**
2002
18 x 24 inches
3 screens

Mission: one poster to advertise four completely unrelated shows at one venue. Solution: four images of two men beating each other with a platypus.

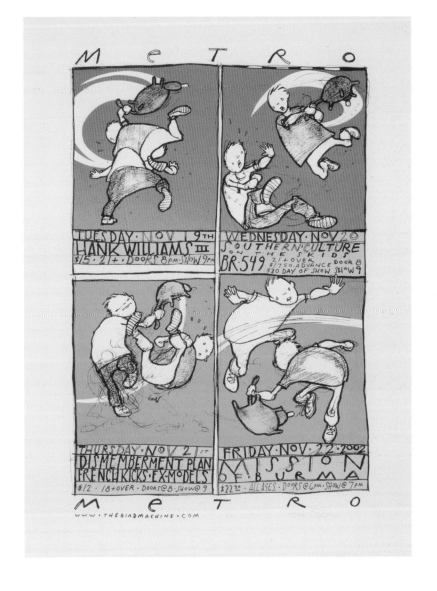

056

**DIANOGAH / RIDDLE
OF STEEL**

2003

12.5 x 19 inches

3 screens

057

MISSION OF BURMA

2002

18 x 24 inches

3 screens

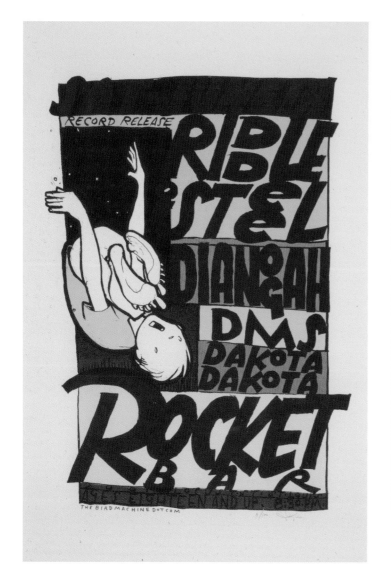

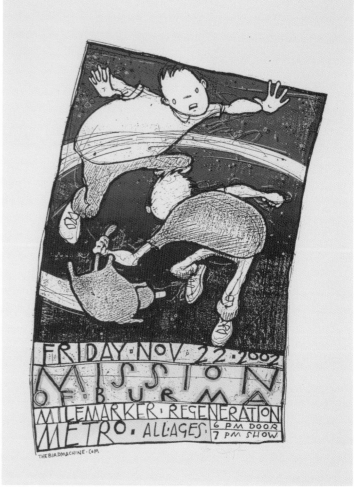

DIANOGAH /
TAKING PICTURES
2002
13 x 18 inches
4 screens

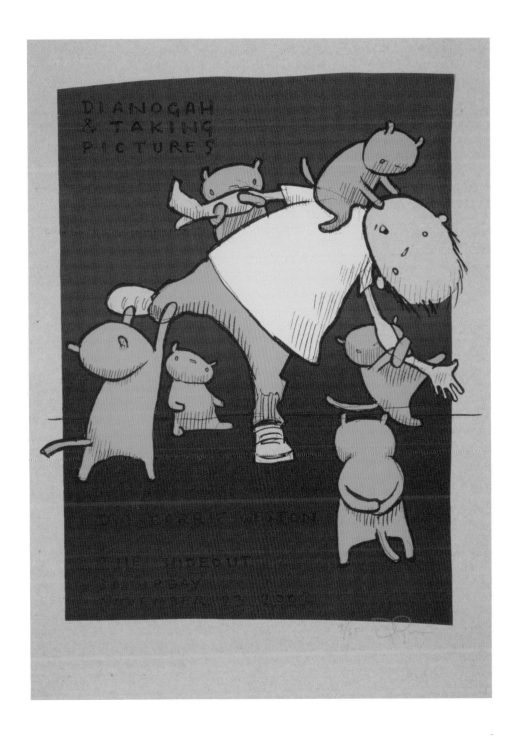

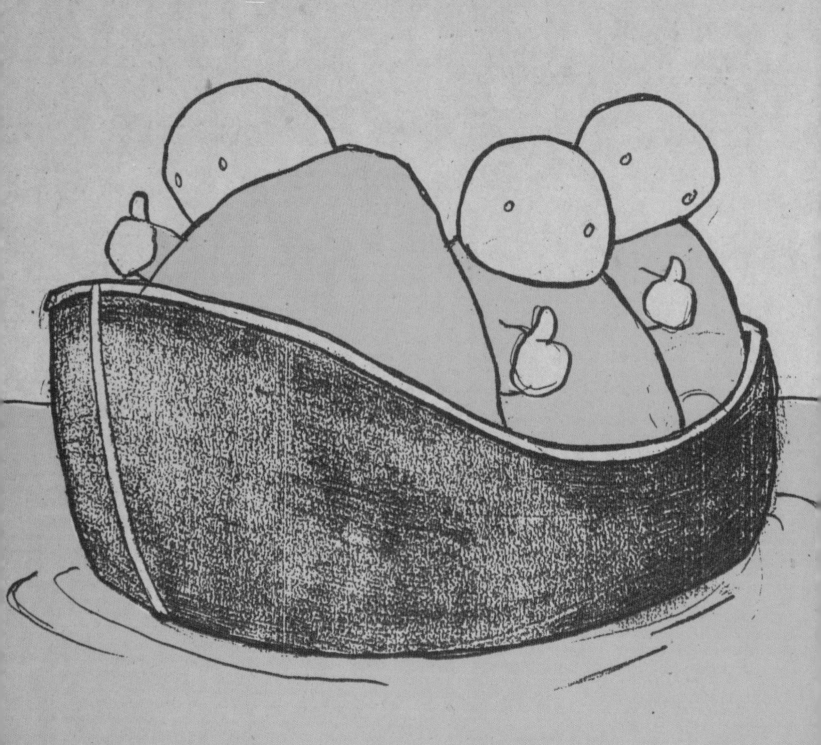

059

**THE SHIPPING NEWS /
DIANOGAH**
1999
11 x 17 inches
2 screens
detail (opposite)

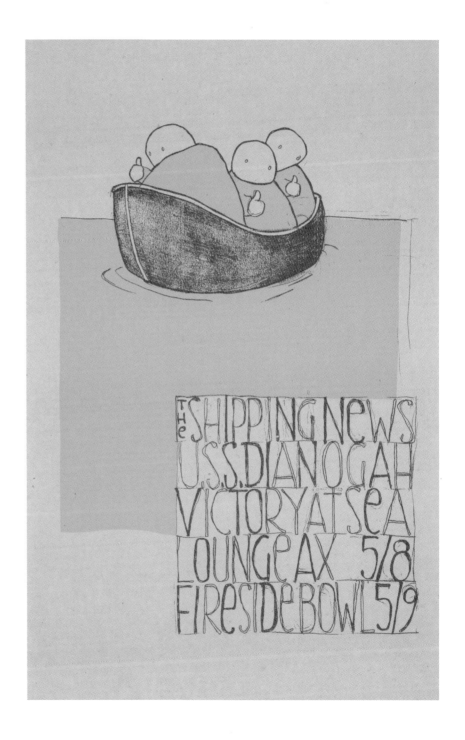

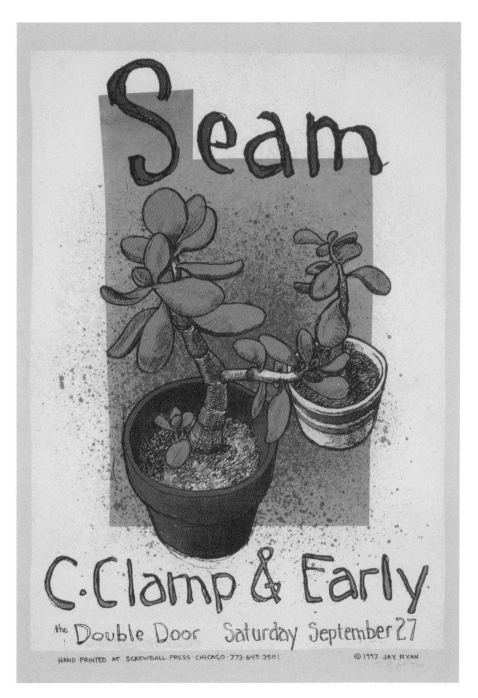

060
SEAM / C-CLAMP
1997
27.5 x 19 inches
6 screens

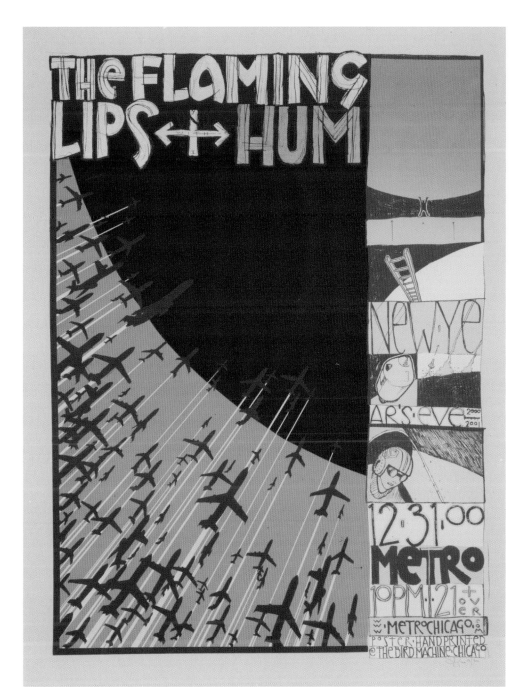

THE FLAMING LIPS / HUM
2000
19 x 25 inches
7 screens

FLATSTOCK 1

2002

12.5 x 19 inches

4 screens

FLATSTOCK 2

2003

18 x 24 inches

6 screens

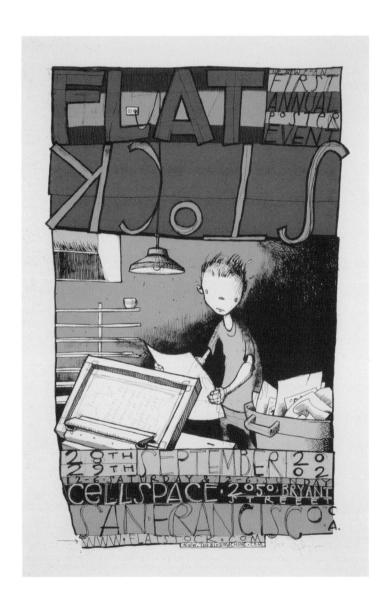

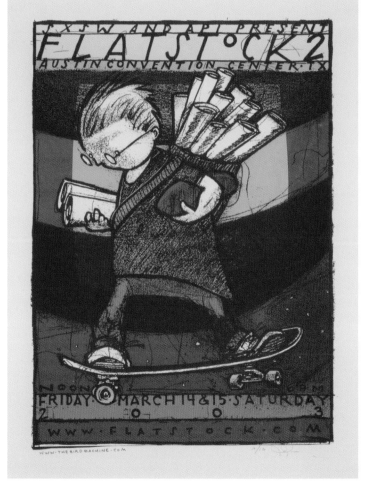

FLATSTOCK 5
2004
12 x 24 inches
5 screens

FLATSTOCK 6
2005
18 x 24 inches
4 screens

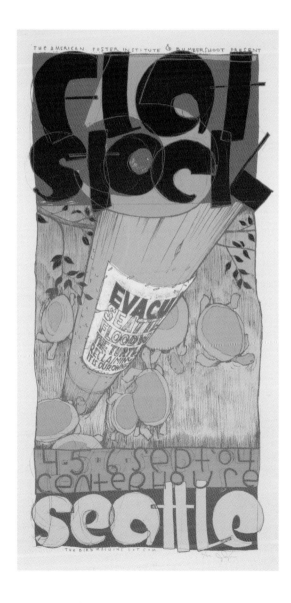

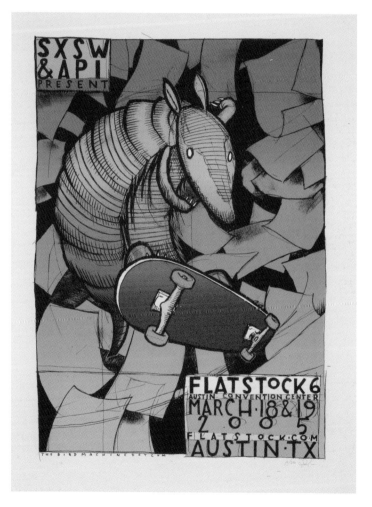

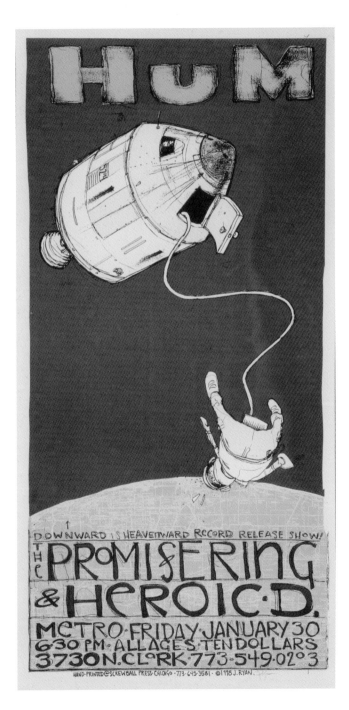

066

HUM / THE PROMISE RING
1998
12 x 24 inches
4 screens
original pencil drawing
(opposite)

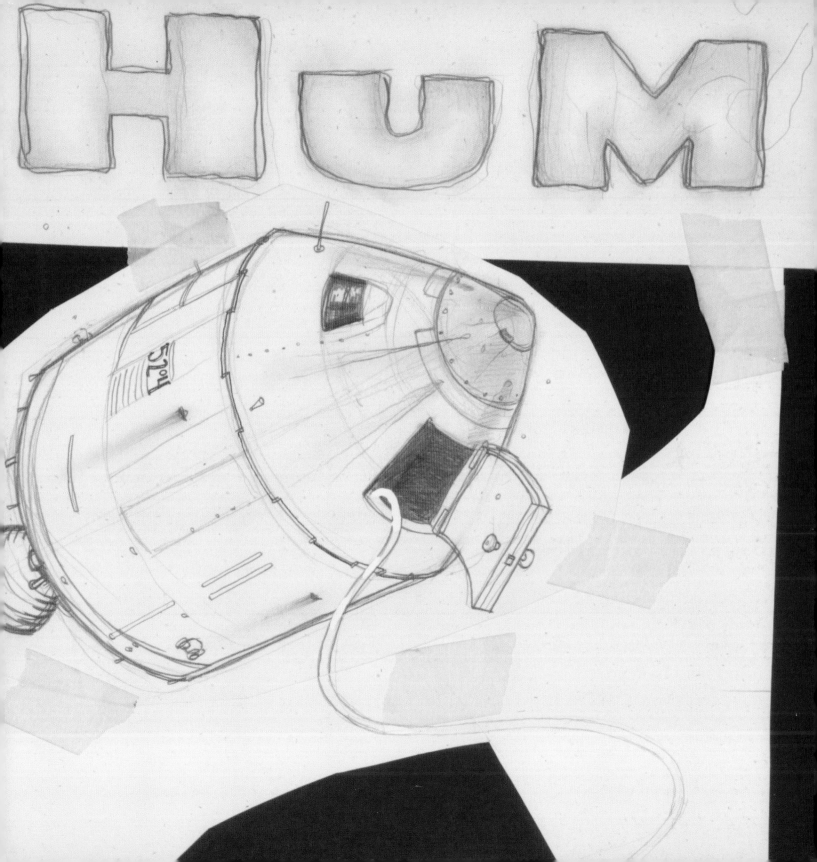

HUM
2003
24 x 18 inches
6 screens

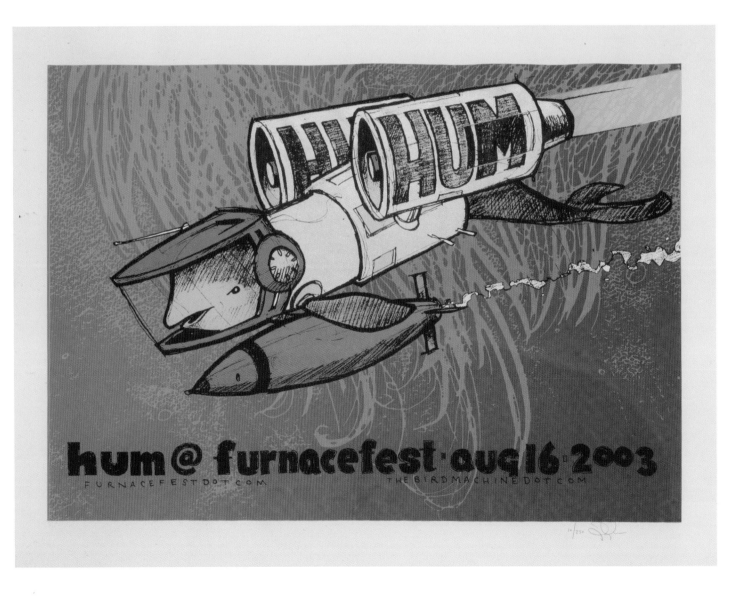

068
MELVINS
2004
20.75 x 15.75 inches
3 screens

069
VERBOW / THE SLUGS
2002
13 x 20 inches
2 screens

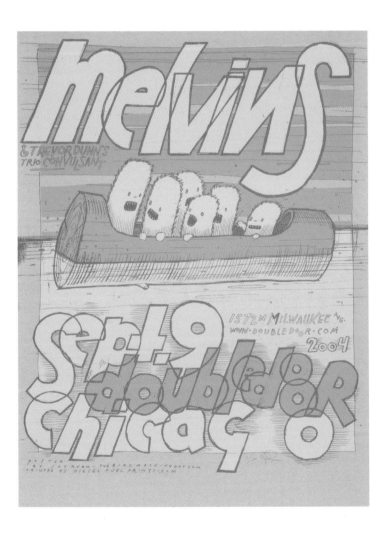

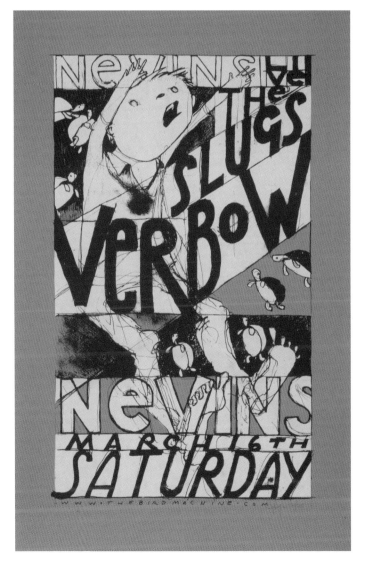

070

JUNE OF 44 / REX
1996
15 x 22 inches
5 screens

071

DIANOGAH / HURL / ILIUM
1997
24 x 36 inches
8 screens

An illustrated autobiographical description of the issues Dianogah experienced in trying to write and record our first album.

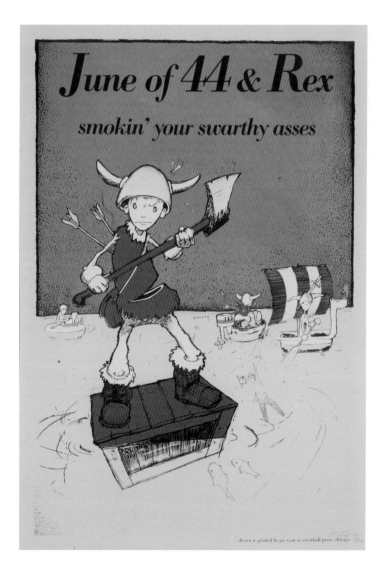

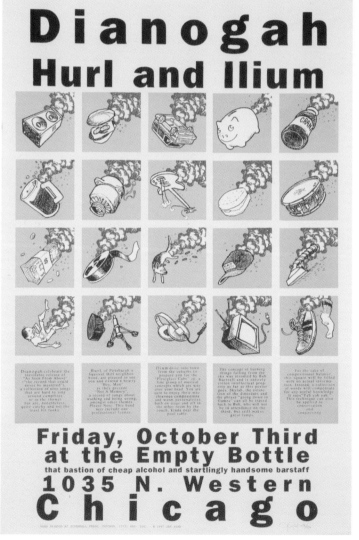

072

**POSTER CHILDREN /
DIANOGAH / CENTAUR**
2002
13.75 x 19.5 inches
3 screens

I racked my brain to come up with every fact I could about wooly mammoths, then wrote them all down on this print. For example: "The wooly mammoths had poor table manners, but they tipped well. The wooly mammoths did not have mobile phones, so they had to use walkie-talkies or complex hand signals to communicate across vast distances. The wooly mammoths were great bargain hunters, but usually purchased goods and services which they did not need or especially want, except as fleeting interests."

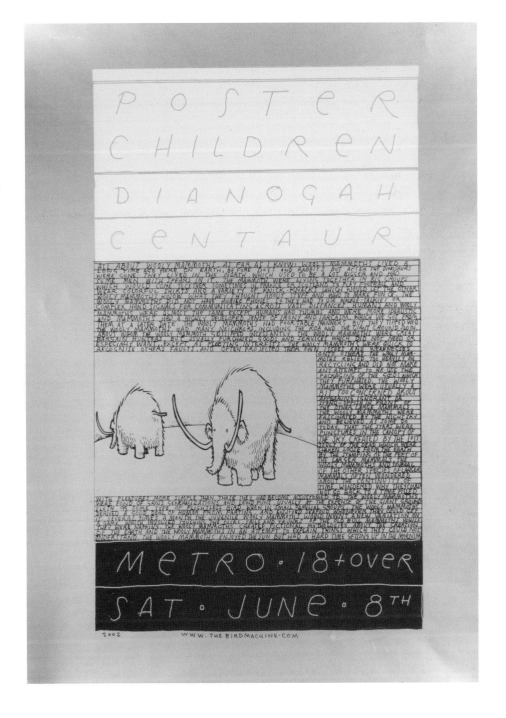

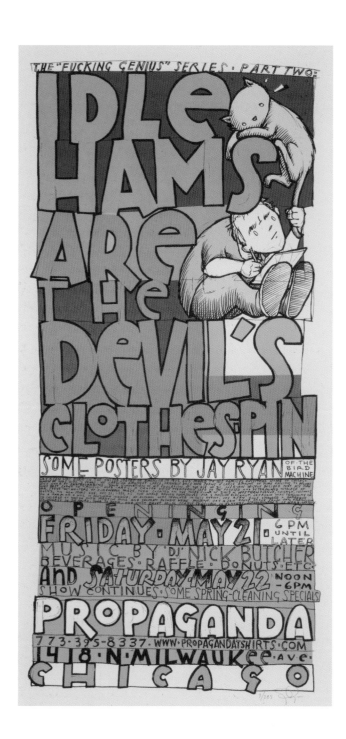

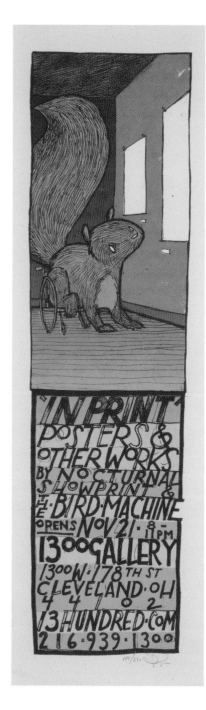

073

**IDLE HAMS ARE THE
DEVIL'S CLOTHES-PIN**
EXHIBITION POSTER
2004
12 x 24 inches
4 screens

074

IN PRINT
EXHIBITION POSTER
2003
8 x 26 inches
3 screens

*This image was loosely
based on a true story:
When we were making this
poster, a friend found a half-
paralyzed squirrel and tried
to have a wheelchair made
for the little guy.*

075

IRON & WINE
2004
12 x 24 inches
4 screens

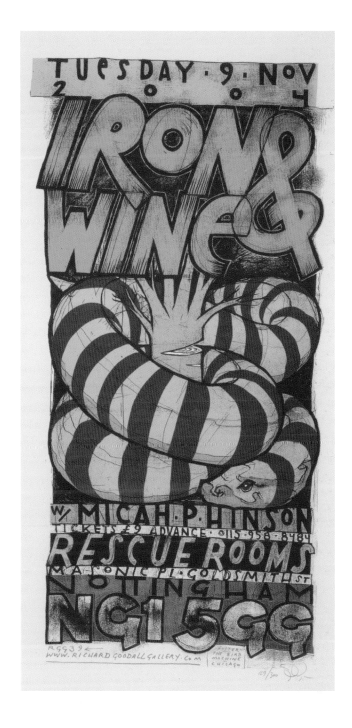

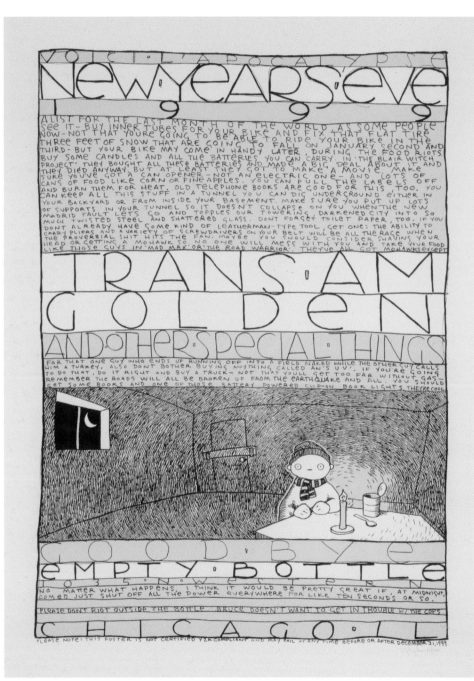

"Y2K" TRANS AM & GOLDEN
1999
18 x 24 inches
2 screens
detail (opposite)

*A to-do list for the night the
world was scheduled to end.*

PRE·L'APOCALYPSE

NEW·YEARS·EVE 1999

FOR THE LAST MONTH OF THE WORLD, AS SOME PEOPLE
BUY INNER TUBES FOR YOUR BIKE AND FIX THAT FLAT TIRE
NOT THAT YOU'RE GOING TO BE ABLE TO RIDE YOUR BIKE IN THE
FEET OF SNOW THAT ARE GOING TO FALL ON JANUARY SECOND AN
BUT YOUR BIKE MAY COME IN HANDY LATER, DURING THE FOOD RIOT
OME CANDLES AND ALL THE BATTERIES YOU CAN CARRY. IN THE BLAIR WITCH
T' THEY BOUGHT ALL THESE BATTERIES AND MADE A BIG DEAL ABOUT IT AND
DIED ANYWAY, BUT AT LEAST THEY GOT TO MAKE A MOVIE. MAKE
YOU'VE GOT A CAN OPENER—NOT AN ELECTRIC ONE—AND LOTS OF
OF FOOD LIKE CORN OR PINEAPPLES. YOU CAN PULL THE LABELS OFF
URN THEM FOR HEAT. OLD TELEPHONE BOOKS ARE GOOD FOR THIS, TOO. YOU
EP ALL THIS STUFF IN A TUNNEL YOU CAN DIG UNDERGROUND EITHER IN
BACKYARD OR FROM INSIDE YOUR BASEMENT. MAKE SURE YOU PUT UP LOTS
PORTS IN YOUR TUNNEL SO IT DOESN'T COLLAPSE ON YOU WHEN THE NEW
D FAULT LETS GO AND TOPPLES OUR TOWERING, DARKENED CITY INTO SO
TWISTED STEEL AND SHATTERED GLASS. DON'T FORGET TOILET PAPER, TOO. IF YO
ALREADY HAVE SOME KIND OF LEATHERMAN-TYPE TOOL, GET ONE: THE ABILITY TO
PLIERS AND A VARIETY OF SCREWDRIVERS ON YOUR BELT WILL BE ALL THE RAGE WHEN
ROVERBIAL SHIT HITS THE FAN. MAYBE YOU SHOULD CONSIDER SHAVING YOUR
OR GETTING A MOHAWK SO NO ONE WILL MESS WITH YOU AND TAKE YOUR FOO
THOSE GUYS IN 'MAD MAX' OR 'THE ROAD WARRIOR'. THEY'VE ALL GOT MOHAWKS EXCE

TRANS·AM
HOLDEN
ND·OTHER·SPECIAL·THINGS

HAT ONE GUY WHO ENDS UP RUNNING OFF INTO A FIELD NAKED WHILE THE OTHER GUY CALLS
TURKEY. ALSO DON'T BOTHER BUYING ANYTHING CALLED AN 'SUV'. IF YOU'RE GOIN
THAT, DO IT RIGHT AND BUY A TRUCK—NOT THAT YOU'LL GET TOO FAR WITHOUT GAS
MBER THE ROADS WILL ALL BE BROKEN UP FROM THE EARTHQUAKE AND ALL. YOU SHOUL
OME BOOKS AND ONE OF THOSE BATTERY POWERED CLIP-ON BOOK LIGHTS, THEY'RE CO

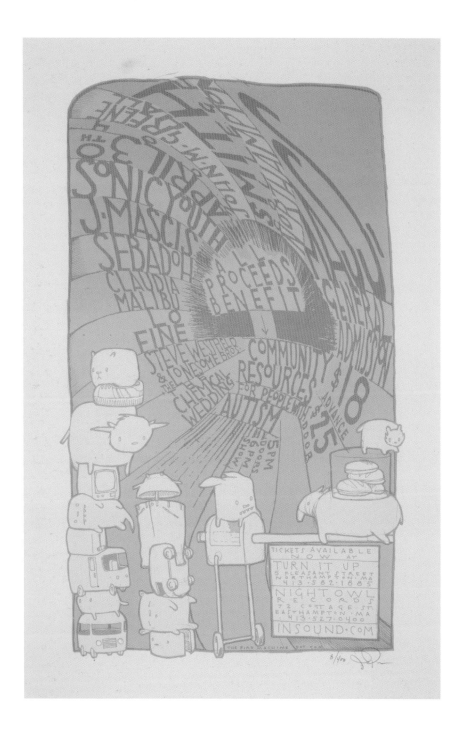

077

SONIC YOUTH / SEBADOH /
J MASCIS
2004
12.5 x 19 inches
3 screens

078

"SONIC HEROES"

2002

14 x 26 inches

4 screens

079

PAUL DUNCAN / SHEDDING

2004

8 x 22 inches

3 screens

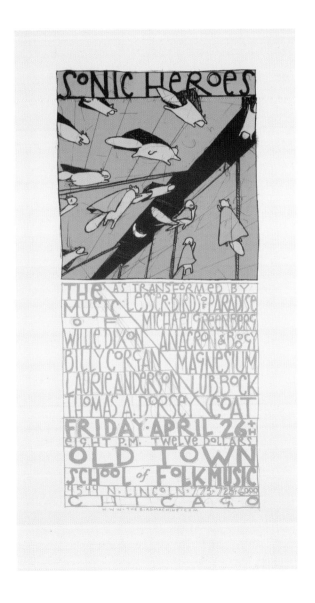

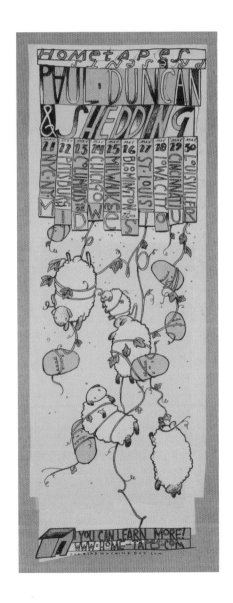

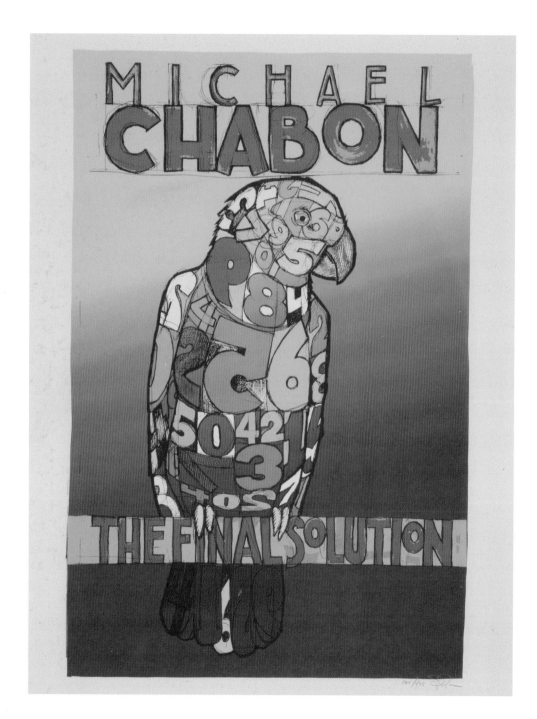

080

MICHAEL CHABON'S
THE FINAL SOLUTION
2004
19 x 25 inches
8 screens

*This started as the cover
illustration, compiled and
colored in Adobe Photoshop,
of Chabon's novella. After
the book was sent to the
printer, we recreated
the image for this poster
through our normal
screenprinting process.*

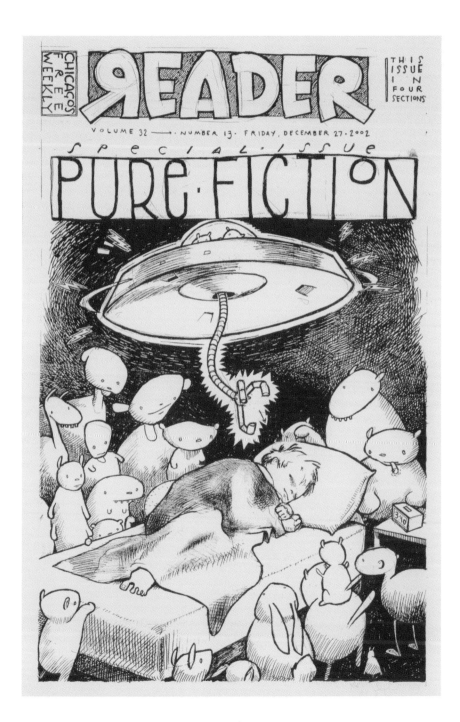

081

CHICAGO *READER*
"PURE FICTION"
2002
15.5 x 24 inches
1 screen

Originally used as the front cover of the Chicago Reader's last issue of the year.

082

36 INVISIBLES
2003
12 x 22 inches
5 screens

083

THE VOWS
2003
12 x 24
5 screens

This poster served as a wedding invitation. I was later given a photo of the best man carrying this print around like a banner at the reception, parading ahead of the bride and groom.

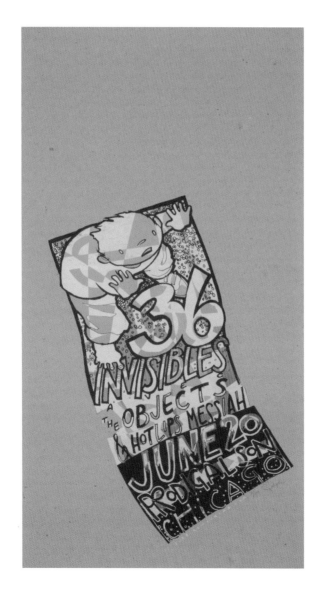

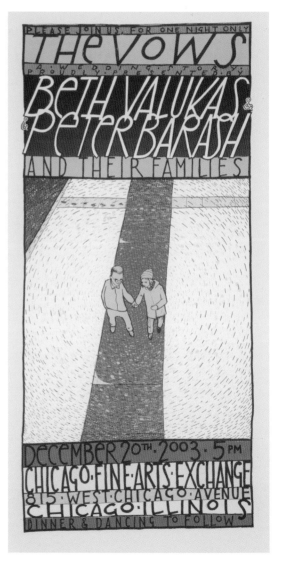

"DON'T GO ALONE"
2003
26 x 32 inches
5 screens

In 2003 I broke my ankle rather thoroughly while skateboarding. After a couple weeks in bed, on heavy pain medication, I finally got myself wheelchaired to the kitchen table, and this was the first thing I drew. Thanks to Mat and Dan for carrying me out of that pool.

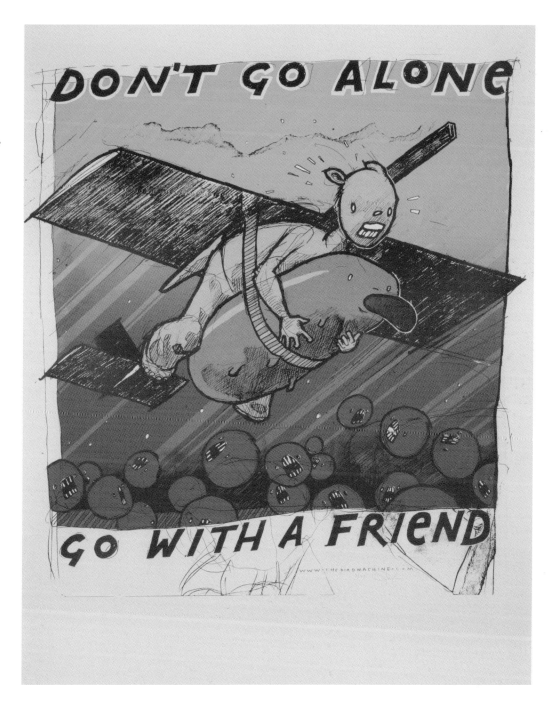

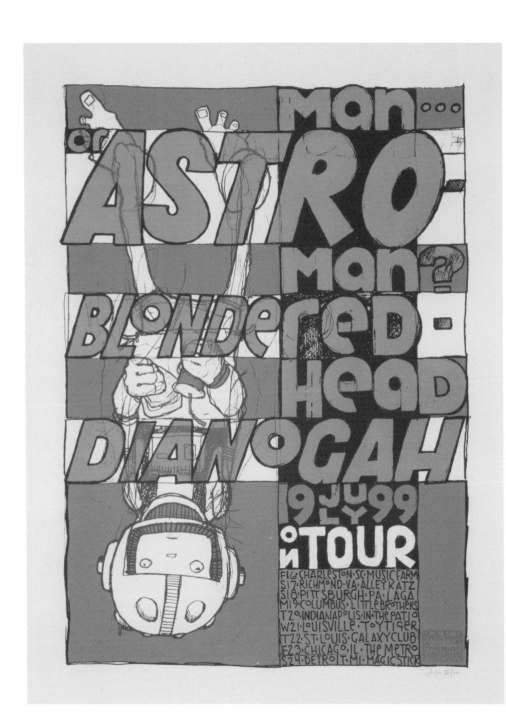

085

**MAN … OR ASTROMAN? /
BLONDE REDHEAD**
1999
18 x 24 inches
4 screens

086

CAPITALISTPIG
1998
17.5 x 23 inches
4 screens

Every cutting-edge asset-management company needs a poster.

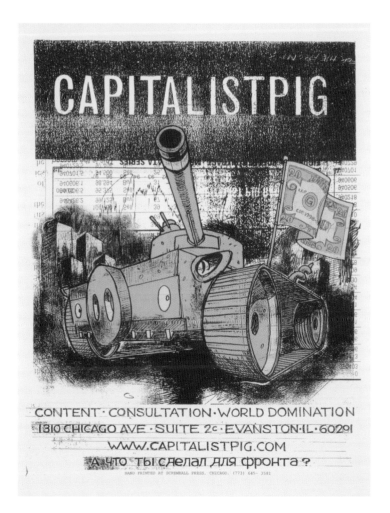

087

PRIME SHORTS
2004
18 x 24 inches
4 screens

A poster for an ambitious film festival run solely by one woman.

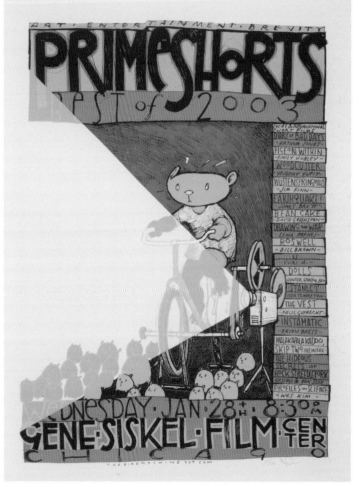

088
**QUEENS OF THE
STONE AGE**
2005
19 x 25 inches
2 screens
detail (opposite)

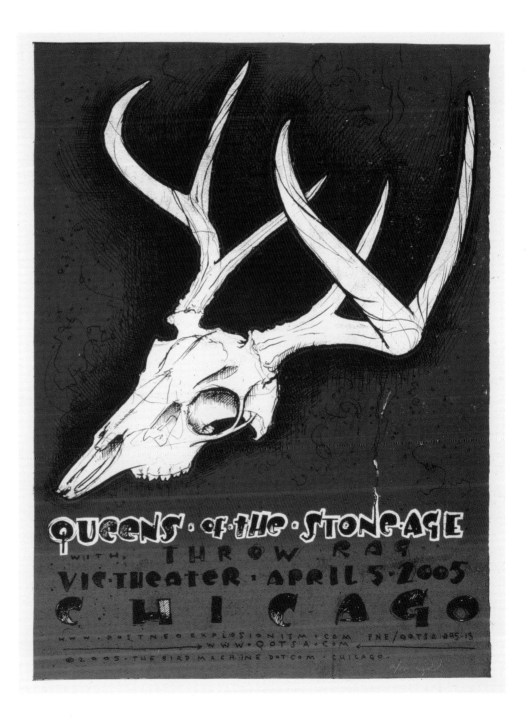

089

NEKO CASE

2004

12 x 24 inches

5 screens

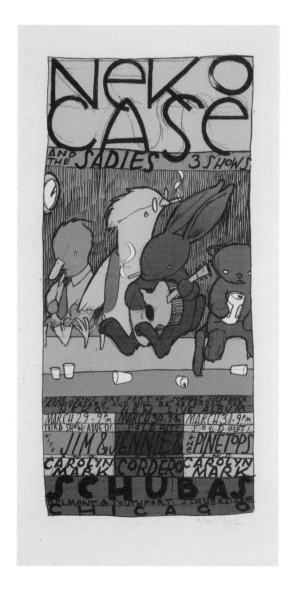

090

BEN HARPER

1998

12 x 24 inches

5 screens

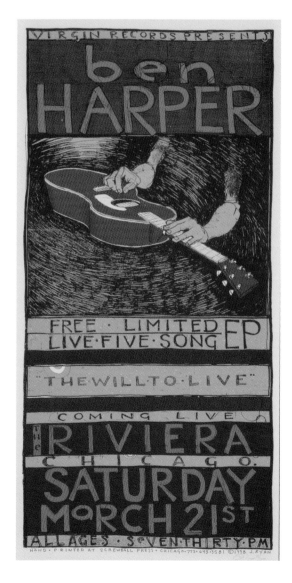

091

DAMO SUZUKI / DEFENDER
2003
12 x 24 inches
3 screens

*I only draw from what I can
see. In this case, it's a bird
and a cat arguing over a
mobile phone and a box
of donuts.*

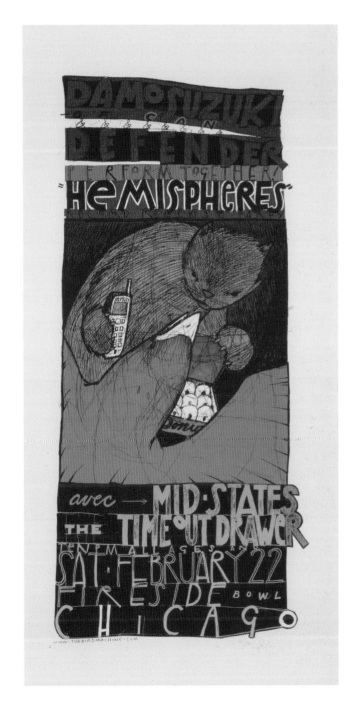

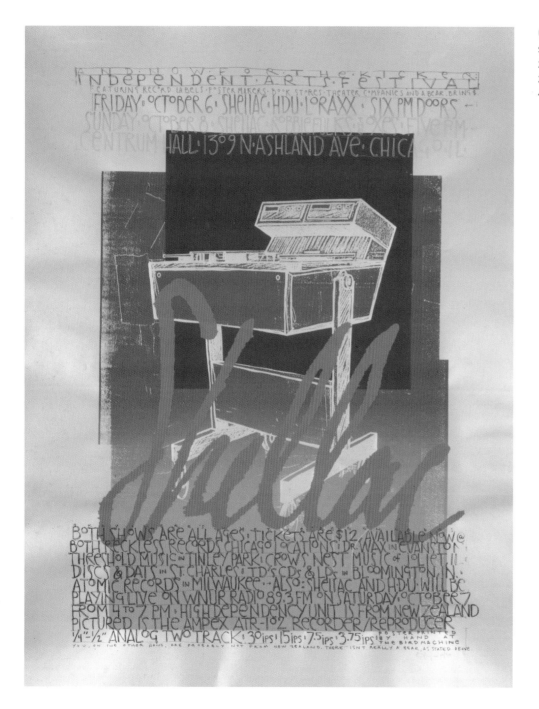

093

SHELLAC "SKONNI TOUR"
2000
20 x 26 inches
7 screens

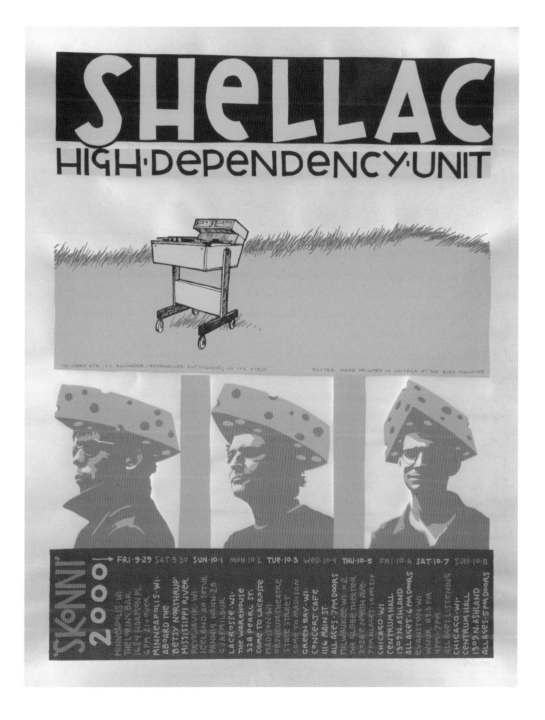

094

STEREOLAB
1997
17 x 21 inches
8 screens
original pencil drawing
(opposite)

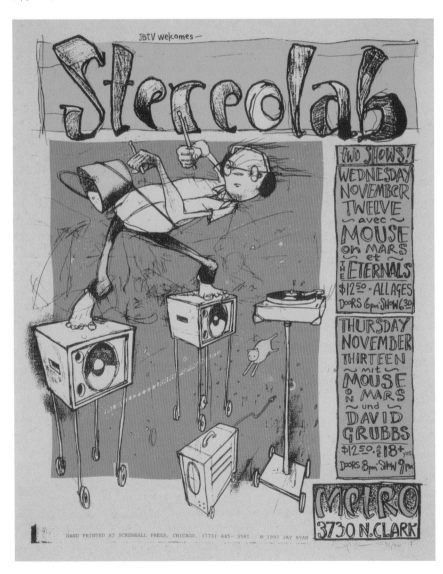

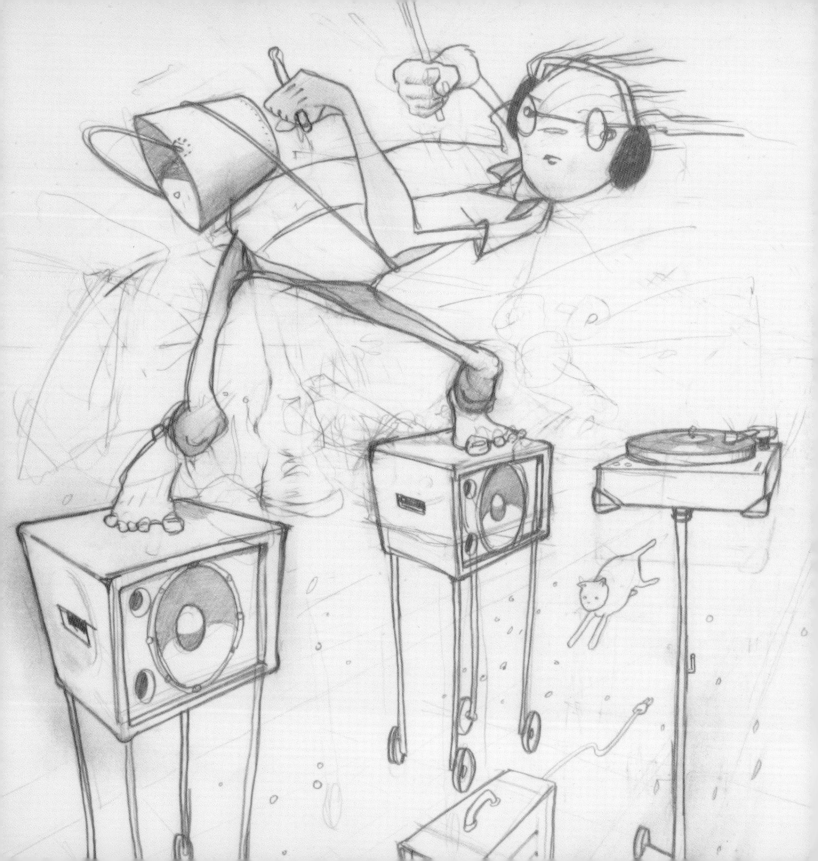

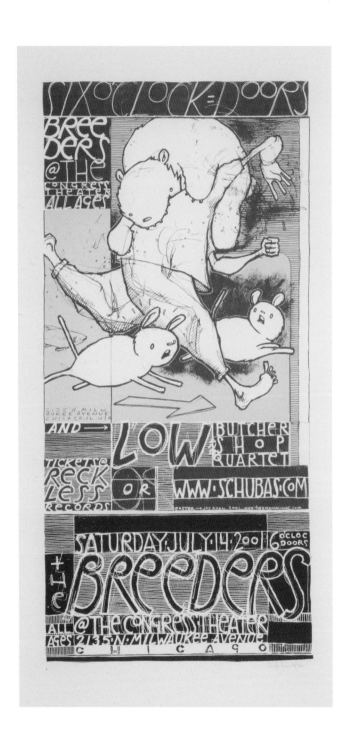

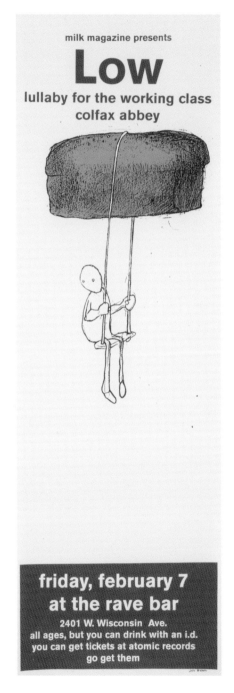

*This is one of the few cases
where I think a computer-
generated typeface was more
appropriate than hand-drawn
type, as it added to the
stillness and emptiness of
the image. Most of these
posters were eaten by my
roommate's dog.*

GUIDED BY VOICES
"FINAL SHOW"
2004
19 x 25 inches
8 screens

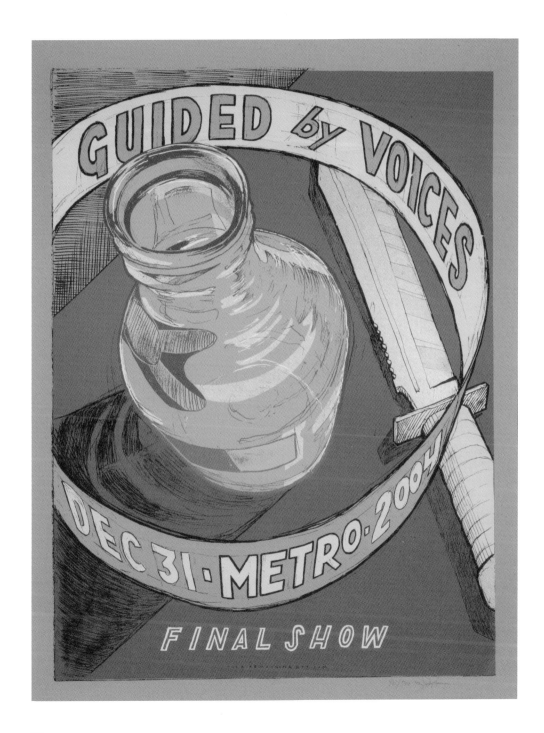

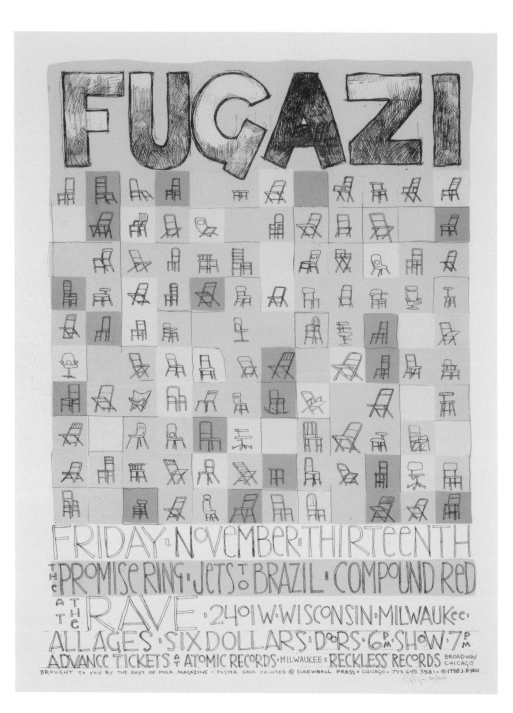

FUGAZI
1998
18 x 24 inches
4 screens
detail (opposite)

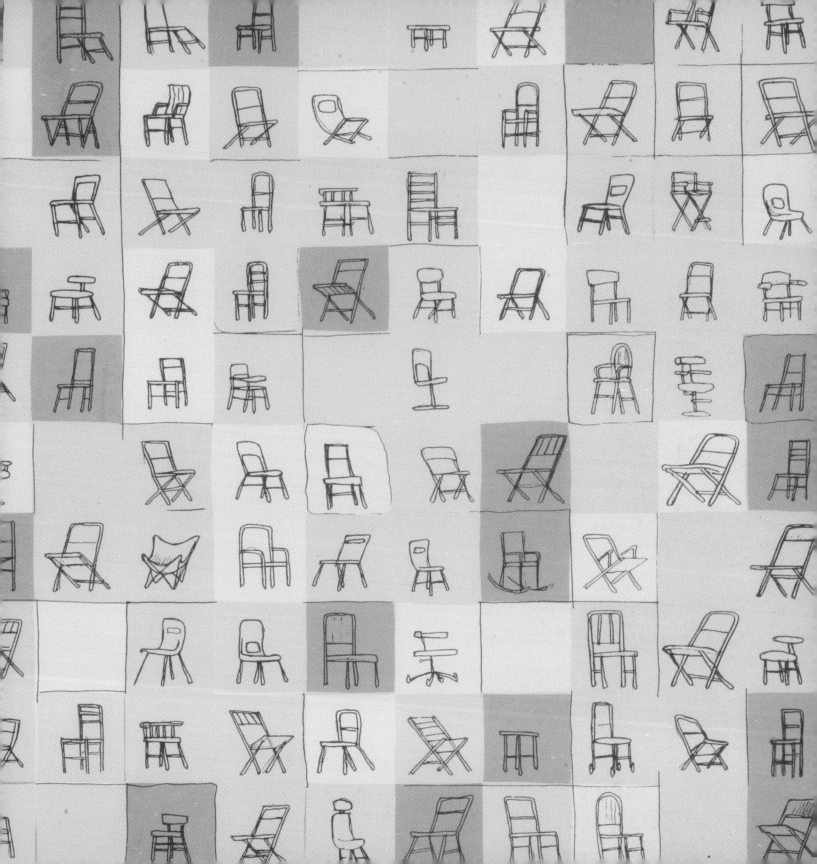

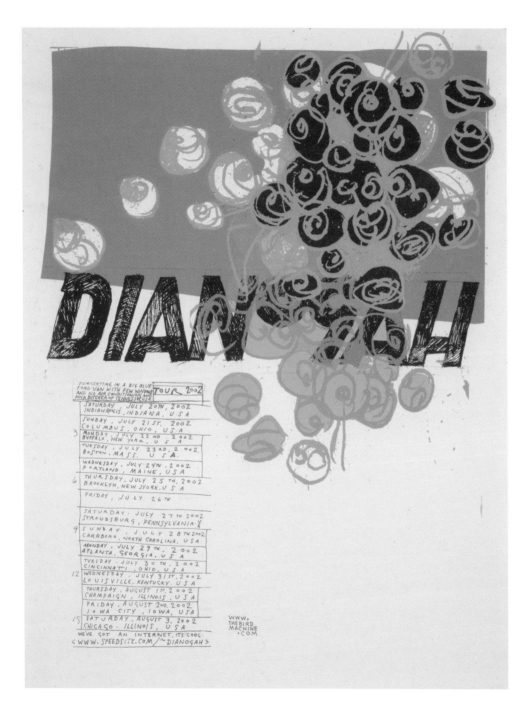

DIANOGAH *"MILLIONS OF BRAZILIANS* **TOUR"**
2002
19 x 25 inches
7 screens

100

**DIANOGAH "SOMETHING
SOMETHING WEST
COAST TOUR"**
1998
18 x 24 inches
5 screens

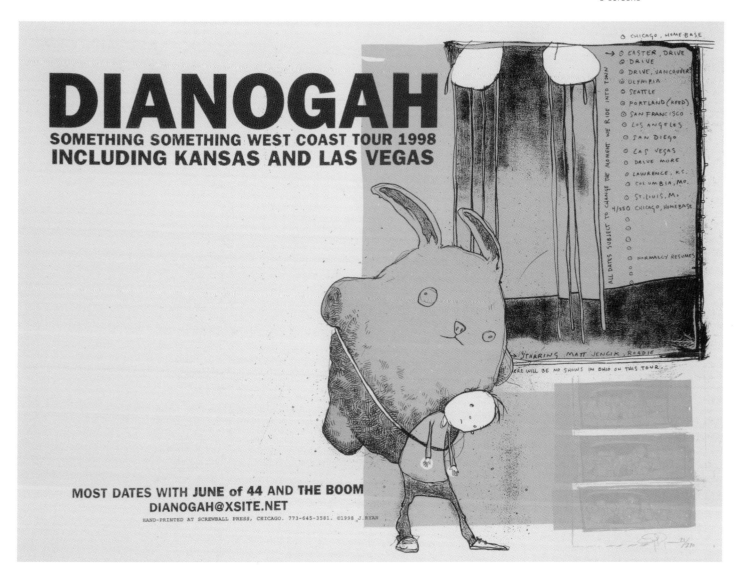

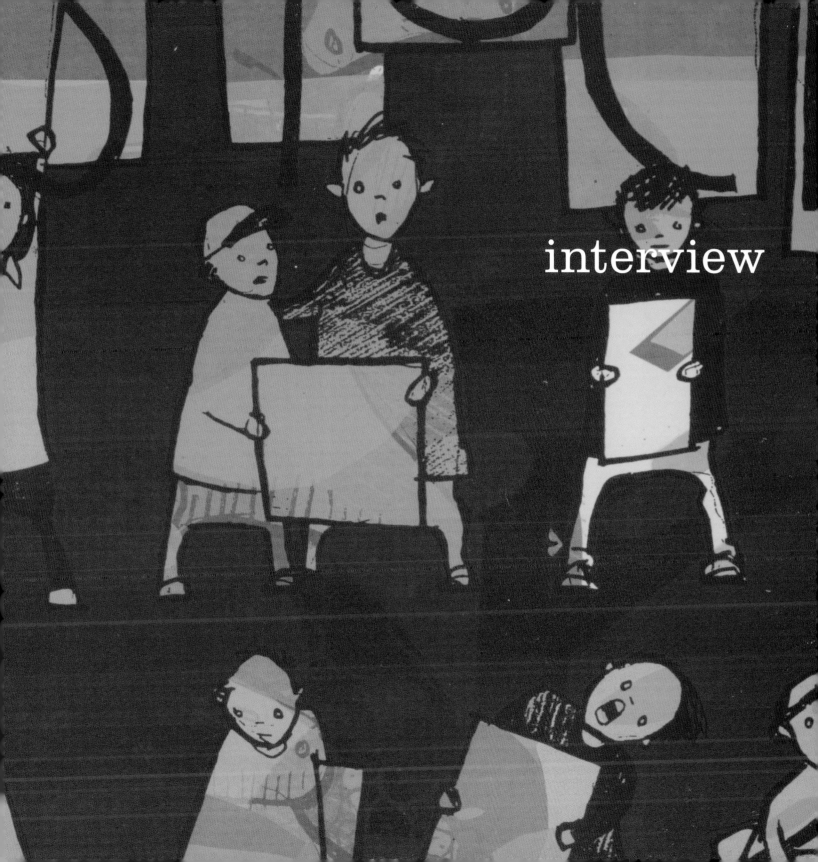

I guess I'll draw some dogs: a conversation

Daniel Sinker

starting with the band

What is your thought process when you sit down to make a poster?

I start, typically, by being aware of who the band is and what they're about. Most of the time I get to work for bands that I'm familiar with, or even a great fan of, or friends with, so I have some idea of what the goals of the band are— whether it's to be loud and crazy, or pleasant; whether their songs are about being drunk, or songs about falling in love, or songs about driving around with a bag of weights in the back of your car. Then I try to use that stuff as a basis for a theme in the imagery, often by going on little tangents. For example, let's say I'm doing a poster and the band's album artwork has a little turtle on it. Well, maybe I'd draw that same little turtle and then flesh it out by doing X, Y, and Z around it. I find that's more appropriate than saying, "Well hey, it's a heavy metal band, so I'm gonna do a pentagram and a hot rod and a monster and some breasts."

Is that how you arrive at most of your images? Because, frankly, it's hard to see. For instance, the Fugazi posters you've made: a line of dogs, a bunch of chairs. I don't see that stuff in the band.

I can argue with you about the chairs, but the dogs were very honestly an act of desperation. "Holy shit, I'm doing a poster for Fugazi and

Shellac, two of my very favorite bands ever. I have no idea what to do. I guess I'll draw some dogs." But the one with the chairs, you can draw parallels between that poster and the interior artwork from the Fugazi album *Steady Diet of Nothing*, which has a photo of a room of empty folding chairs. Also, they have the song "Waiting Room" and another called "Furniture," so there are parallels to be made.

Watching you work, it's surprising how few false starts seem to get made on an image.

You haven't noticed the piles of eraser shavings.

That's true—you do a lot of over-drawing—but oftentimes it seems like you sit in front of a blank sheet for a rather long time and then, suddenly, there will be a drawing. Much of your process happens in your head before it hits the paper.

I think that's probably right. One of the things I had to overcome in college was over-thinking my paintings before they got made. I'd put a line on the canvas and sit there and picture where that painting was going, what it was going to be doing, and then I'd picture it finished and see in my head that it wasn't something I was very happy with, so I wouldn't see any purpose in actually *making* the painting. I was really kind of freezing up as far as getting anything done.

Four of the roughly 300
paintings from the "Quantity
Over Quality" series, fall
1993. Mixed media on
board. Each approximately
5 x 8 inches.

 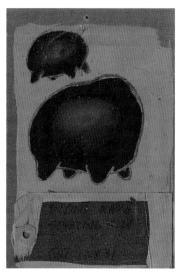

The greatest thing I learned in college was taught to me by a professor named Peter Kursel, who got me to sit down with a stack of paper I'd found in a dumpster and draw on every sheet before I got up and left my studio again. I sat down on a Saturday and worked for something like eight or ten hours, and when I was finished I had this big stack of 300 really terrible drawings. But that forced me to actually make a lot of things and not worry about if they're good or not. Learning that led me to spend about six or eight weeks making 300 small paintings, which I displayed all together. Individually, most of them are boring—stupid little smudges and logs and Jackson Pollock–looking splatters and little stupid figures and everything—but when you put them all together, it creates something greater than the sum of its parts.

That was the mode in which I was working when I started making posters; I don't know if I've kept that up very well. Sometimes I'll be sitting in front of the blank page for two days, and suddenly I'll be like, "Oh! Of course! It's this or that," and it's very easy then and comes out in a matter of hours. Other times it's a matter of drawing a line and asking, "What's this line doing? Is it somebody's spine? An arrow? Is it a stink line coming off of something?" Then it's

A rare photo of Steve Walters
working round-the-clock at
Screwball Press, circa 1997.

just a matter of connecting the dots and figuring out where that is and where the edges of the page are and working that way.

the rock poster

How did you first get involved in making rock posters?

All through high school I thought I was going to be an architect, but when I got to college I couldn't get into the architecture program at the school I was attending. Instead, I ended up painting my sophomore year. A lot of the work that I was doing there had somewhat nonsensical text attached to the images.

When I got out of school, I was still doing paintings, but part of me had doubts about the validity of making these images without some

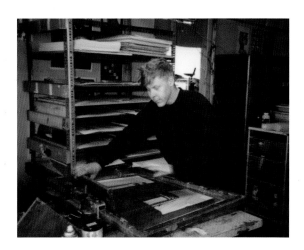

type of meaning behind them, and I didn't think they really meant much of anything at all. This whole time I was playing in bands and doing freelance illustration. I got a job designing a poster for the Supersuckers, Rocket from the Crypt, and Wesley Willis through Andy Mueller at the design company Ohio Girl. We met up with this screen printer, Steve Walters, at Screwball Press, and what Steve was working on there—these crazy, ridiculous, nonsensical images with some type of depiction of the band or the experience of seeing the band, or the music, or the feeling just written out in words on the poster—was something I identified with immediately. I thought that it was really great that you could have words and images that were tied together on one surface that served a purpose, but were also loose and potentially "silly" or casual.

Was the rock poster something you were familiar with before going to Screwball?

No, not really. Although I had been playing music and been in bands, my experience with posters had either been Xeroxed flyers or offset posters that came from the record company—the album cover, basically, with a white space on the bottom—or Grateful Dead posters. My own bands and my friends' bands were always Xeroxed-flyer bands—I made maybe half a dozen flyers for my own band, but it was something that I didn't take seriously.

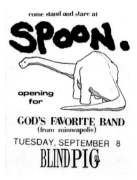

Xeroxed flyers for Dianogah's first two shows, 1995, and Jay's old band, Spoon (no, not *that* Spoon), 1992.

Dianogah playing at Lounge Ax on the club's last night, January 15, 2000.

Was screenprinting new to you?

I'd taken etching courses in college, but I'd never done screenprinting. To come in and see all these screens and this press and this ramshackle garage-sale of a print shop, with stacks of posters and images and piles of paper and jars of ink and people working around the clock—I really wanted to be involved in what was going on there.

How did you get involved?

Well, I went home after making that first poster and designed one for my own band, Dianogah. I went through the whole process we had gone through for that first poster and went over to Screwball Press, knocked on the door, and said, "Hey, I'd like to have you guys print this." After that, it was just a case of hanging out and not leaving, which was kind of the impression I got of how everyone ended up there.

How long were you at Screwball?

I got ingrained into the Screwball mesh over the course of a couple of months, starting in November of '95. By February or March of '96, I was probably spending most of my free time there. I was there on and off, depending on my job situation, until the end of '98 when Screwball lost their lease and moved out of that space. After that, I took some equipment I had acquired and moved it into my basement.

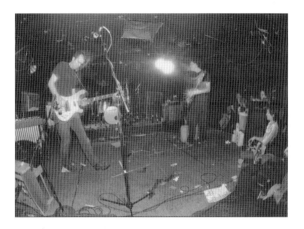

the bird machine

When did you begin to print exclusively out of your own space?

In early '99. There was a Built to Spill poster for a show at the Metro that was started at Screwball Press—which at that point was in Steve's basement—and the last couple of colors were pulled in my basement, at the Bird Machine. I gutted part of the basement, hot-rodding this bad old T-shirt press into one suitable for graphic work, taking a scrub sink and building it into a little enclosure where I could spray out screens, putting a darkroom in a closet for coating screens, making a light table out of two-by-fours and a piece of glass from a garage-sale coffee table, and building a big work table out of a section of bowling alley floor.

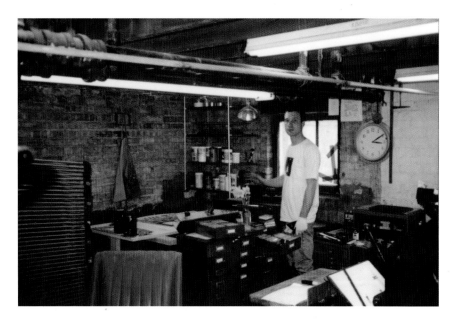

Chad Smith visits the "old" Bird Machine shop, in Jay's basement, circa 1999.

After a number of months printing by myself, however, I realized that I could have somebody else print while I was still sitting upstairs drawing the next poster. My friend Mat Daly moved from Pittsburgh to Chicago and was really interested in what I was doing, and flexible enough with his schedule that he was able to come and start working for me.

How big were your print runs back then?

The first year, I'd do runs of 50 to 100 pieces. After that, my standard run became between 200 and 300 pieces, but creating those prints took a long time. For every day we were working, we were printing maybe 600 pulls at most, which, if you're doing an edition of 300 posters, is only two colors, and most of what we were doing was four- or five-color posters.

Back then we were doing more printing for other people—which I've mostly sworn off of at this point—and printing more things that, after they were finished, I wouldn't really want anyone to see. Those are the kinds of things that aren't documented on my website or in this book. This book is 100 posters I'm really proud of. Maybe there will be another book that'll be 400 posters I don't want you to see.

You moved out of your basement and into your current printshop in 2002. What prompted that move?

First and foremost I needed more space. We were working in a basement which had ceilings that were 6'2", and I'm 6'4", so I had a ritual of hitting my head on the ceiling three times a day. Also, I wanted some separation between work and home. It was nice and ideal to be able to roll out of bed and work in my underwear or work all night—which occasionally still happens—but where I worked and where I

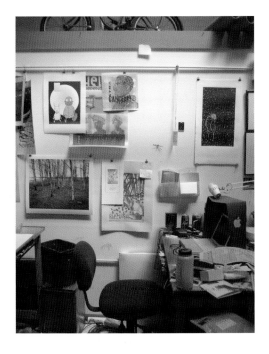

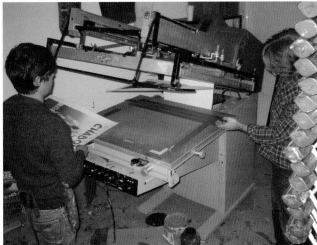

From bottom left to right: Jay's work area, circa 2004. Mat and Kevin printing Chabon posters, 2004. The "Megan Chance Memorial Exposure Unit," with debris.

lived were starting to flow into each other, and not necessarily in a good way. Plus, it was just nice to get out of the basement.

Although you moved into a much larger space, your method of working stayed largely unchanged until the purchase of a semi-automatic press in 2004. Why?

I didn't think there was any need to change until we got to the point where we were doing so much volume that Mat and I had damaged our wrists to the degree that we couldn't pull screens well anymore. It was really difficult to pull 300 four-color prints; to do it again two days later became impossible, and so we moved to having a semi-automatic press, which is the only real change we've made to our equipment of any note.

But getting that press was a huge thing for your shop. It changed what kind of jobs you could say yes to.

That's true. We did take on very large jobs beforehand, but I was a bad enough businessman that they were just an enormous waste of time—

like stupidly hand-printing 11,000 two-color LP sleeves for $900. Now, we're in a much better place to take on larger runs if we choose to, but that's not necessarily the nature of our business.

lettering

When you were starting out, how was your approach to your work different than how you approach it now?

There was a lot more experimentation. There were no expectations of "it has to look like this" or "it's supposed to look like that."

At the start, were you just using computer type?

Not exclusively. The first poster I did used computer type that had been manipulated by hand—the edges were messed up by pen and ink.

What made you stop using computer type?

As I became more aware of what other people were doing—different poster-makers in Chicago

Type treatment:
a hand-drawn ampersand vs.
one set in Clarendon.

and around the country—I saw a lot of things I liked and didn't like. I'd seen a lot of work by Derek Hess from Cleveland and I thought his images were great, but in a lot of cases his type was not nearly as interesting as his drawings. That made me kind of look at my own work and wonder, "Is my type boring?" At the same time, I had a show in Seattle with Art Chantry, Justin Hampton, Shawn Wolf, and Ellen Forney, and I heard that Chantry had said that he really liked my posters but that the digital type was shit. After that, I put a lot more effort into my hand-drawn type.

How did moving to predominantly hand-drawn type change the way you approached your posters?

When I use computer type, I create an image and then I put a frame on it. The frame has text, and the image is the part in the middle. When you're drawing both the images and the type, there's not such a distance between the visual information and the useful information, so I think it's easier to tie the image and the information to each other.

rock-poster community

At around the same time you began to print regularly under the Bird Machine name, it seems like there was something of a resurgence in handmade rock posters happening nationwide. What do you think prompted this phenomenon?

I tie that to a website called Gigposters.com that was started in 2001 by Clay Hayes up in Calgary. I believe he started it as a fan site for one or two people he knew who were making posters. Then other people submitted scans of their collections and joined the message boards. Soon more and more people found the site.

Before Gigposters.com, I didn't know of many other poster artists outside of Chicago. There were six or eight people in Chicago putting real time into making posters—Crosshair Press, Screwball Press and its various members, and then the Bird Machine—and beyond that I knew there was this guy in Texas

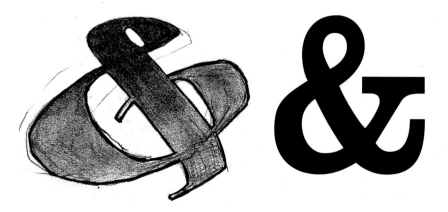

Michael Chabon's *The Final Solution*, published by 4th Estate, held by a weird-looking human appendage.

named Frank Kozik who did these weird, brightly colored posters, and there was this guy Coop—Chris Cooper—who did all these devil girls, and there was some guy in Portland named Mike King, but I hadn't seen much of this work. All of a sudden this website showed up, and over a very short period of time all these people joined it and so you went from having these little tiny isolated communities where there's one dude in Orlando—or Boston or Portland or Seattle or Vancouver—and suddenly we're all aware of each other. It's a

very strange experience to have happen over such a brief period of time, and it led to all sorts of trouble—in good ways.

Did having this community emerge overnight—and all of these various local styles and influences that now became accessible—open up new possibilities for you in terms of what you thought you could be doing with your posters?

Well, it was inspiring, of course, to see such a variety and volume of work, and I love picking up on details of other people's work, but I don't think that overall it greatly changed the direction of my own stuff.

the present and the future

The scale of the projects you've done in the last year seems to be quite a bit bigger than in the past. Sometimes it's literally big, like the 100-foot-tall Converse billboard, and other times it's much more visible jobs, like the cover for Michael Chabon's novel *The Final Solution*.

While I'm trying to continue doing small band posters, there have been people looking to hire me who have interesting, large-scale projects where there's going to be more visibility for the artwork, more money for my time, and they are things that I can stand by and agree with. If Marlboro called, I would probably not take that job. But if Michael Chabon wants the new cover

Billboard for Converse shoes, on display at the corner of Wabash Ave. and Ohio St., downtown Chicago.

themselves are something I've worn my entire life, and the parameters of the job were exciting and agreeable. I was called by an ad agency in California and asked to do an illustration for a billboard using the themes of "individuality" and "creativity," and the kicker was that they said no actual shoes and no text needed to be in the image.

How do you see this work changing what you're doing? Even thinking of the rock posters you've done over the last year or so, there are a lot less unknown bands, and many more bands like Queens of the Stone Age and Guided by Voices.

I think one side of that is simply that I don't go out as much anymore and I don't have as many friends in bands. I have many, many friends who *used* to be in bands and no longer need posters. But it's true that now I do get calls to do things for larger bands more than I used to. I guess I'm doing the same thing as I've always been doing, it's just a matter of who's writing me an e-mail and asking me to make posters.

for his book done, there's nothing disagreeable about that; he's one of my favorite authors, and the fact that there's a budget there to pay for the scale of the project helps as well. In terms of the Converse billboard, I took it because—despite the fact that Converse is now owned by Nike, which I don't like—Converse shoes

Where do you see your career going forward from here?

That's something that I have been talking about with Derek Hess. He doesn't do as many show posters as he used to. He spent ten or twelve years doing really great posters for bands you never heard of, and he looks at that work as having created an audience. Now, his

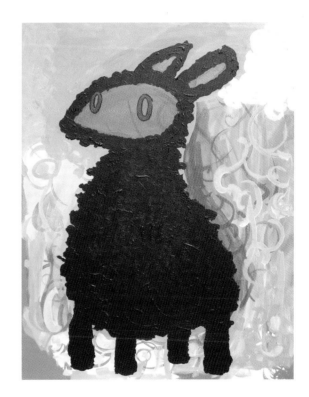

Untitled painting
Spring 2005
24 x 30 inches
Acrylic on canvas

posters don't have to have the band name to get people to pay attention to them; now he can just do what he likes. I think that's admirable. I think that's what Frank Kozik is doing as well. I don't have any solid plans for the future, but I can imagine myself tending toward the Kozik path of being a little more scattered and a little more self-indulgent in my projects, like thinking it would be very funny to do a huge run of 20-color posters of something ridiculous and then trusting that because it is an image that I think is funny, that there will be other people that think the same thing.

Just a couple months ago, I was invited to be in a painting show, so I started painting again for the first time since getting out of college. I did these ten paintings that served no purpose and I had a great time doing it. Though I did fall back into the same moral quandaries I had when I was in college—wondering what the message was, what the purpose was, why anyone would be interested in seeing these things because they weren't tied to some sort of an event to lean on—in the end, it was just fun to sit and paint on these canvases in my basement.

But I have a long way to go. I'm not a master of anything. I have been doing this longer than most of the other people in Chicago, and that gives me some degree of notoriety, but I still have a massive amount of work to accomplish.

poster index

Books, posters, and rock concerts are all, to one degree or another, the products of group efforts. There are many important people who have had a hand in the posters contained in this book and I'd like to be able to thank them all but I can't. If you're reading this, you're probably one of those people. Thank You.

I would like to specifically thank the people who've had a direct hand in making this book, though.

Dan Sinker, Anne Elizabeth Moore, Jason Harvey, Johnny Temple (and everyone at Akashic Books), Lisa Predko, Debra Parr, Art Chantry, Steve Albini, Greg Kot, and the Bird Machine Home Team: Mat Daly, Kevin Duneman, Nick Butcher, Dan Grzeca, and especially Diana Sudyka.

—Jay

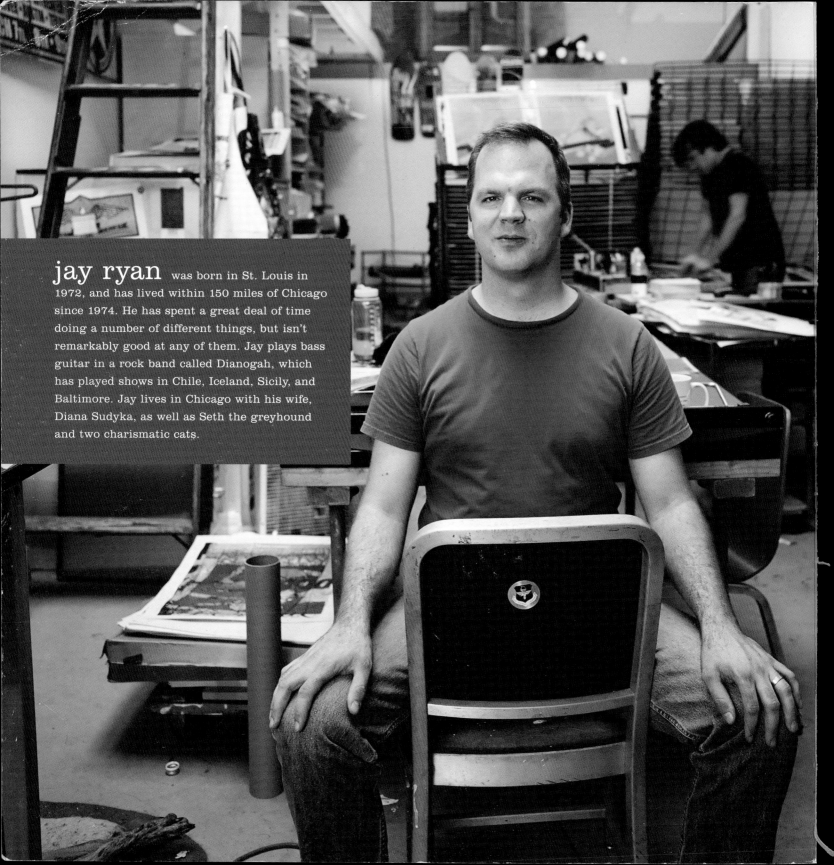

jay ryan was born in St. Louis in 1972, and has lived within 150 miles of Chicago since 1974. He has spent a great deal of time doing a number of different things, but isn't remarkably good at any of them. Jay plays bass guitar in a rock band called Dianogah, which has played shows in Chile, Iceland, Sicily, and Baltimore. Jay lives in Chicago with his wife, Diana Sudyka, as well as Seth the greyhound and two charismatic cats.